HOW TO INSURE YOUR ⊚ LIFE

A Step by Step Guide
to Buying the Coverage
You Need at Prices
You Can Afford

W9-BLF-745

REG WILSON AND
THE MERRITT EDITORS

MERRITT PUBLISHING
A DIVISION OF THE MERRITT COMPANY
SANTA MONICA, CALIFORNIA

How to Insure Your Life
A Step by Step Guide to Buying the Coverage
You Need at Prices You Can Afford

First edition, 1996
Copyright © 1996 by Merritt Publishing

Merritt Publishing
1661 Ninth Street
Santa Monica, California 90406

For a list of other publications or for more information from Merritt Publishing, please call (800) 638-7597. Outside the United States and in Alaska and Hawaii, please call (310) 450-7234.

Library of Congress Catalogue Number: 96-075090

Reg Wilson and the Merritt Editors
How to Insure Your Life
A Step by Step Guide to Buying the Coverage
You Need at Prices You Can Afford.
Includes index.
Pages: 277

ISBN: 1-56343-135-1
Printed in the United States of America.

ACKNOWLEDGMENTS

Reg Wilson would like to acknowledge the many clients, attorneys, CPAs and business managers who supported and encouraged him to write this book; his staff; Julie Payn, who put in long hours of editing and typing; Gina Ross, "who has been there like a rock". Finally, Jan King, Jim Walsh and the editors and staff at Merritt Publishing, without whom this would never have happened.

The Merritt Editors who contributed to this book include Cynthia Davidson, Jan King, Megan Thorpe and James Walsh. Thanks also to: Kimberly Baer Design Associates, Kathie Baumoel, Cynthia Chaillie, Ginger McKelvey and Mimi Tennant.

Some forms that appear in this book are based on standard forms and information used with the permission of the the Insurance Services Office.

How to Insure Your Life is the second book in Merritt Publishing's *How to Insure...* series. Upcoming titles will include *How to Insure Your Home* and *How to Insure Your Income*.

Because these books are designed to make the concepts and theories of insurance understandable to ordinary consumers, the Merritt Editors welcome any feedback. Please fax us at (310) 396-4563 or call (800) 638-7597 during regular business hours, Pacific time. More information from Merritt Publishing is available on the InsWeb Internet site and at http://www.merrittpub.com.

TABLE OF CONTENTS

TABLE OF CONTENTS

CHAPTER 1

WHY YOU NEED LIFE INSURANCE

INTRODUCTION

Life insurance has been bought and sold in the United States since the mid-1700s, but it wasn't until the 1840s that the industry made a significant impact on the American business scene. Since that time, **individual life insurance** has grown steadily, due primarily to the agency distribution system.

Life insurance plays an important role in the financial planning of many families. More than 80 percent of American households have purchased individual life insurance policies.

In the purest sense, life insurance is something that pays a **death benefit** to someone when **an insured person** dies. The primary purpose of life insurance is to protect against the risk of **premature death**—dying too soon.

Premature death exposes a family or a business to certain financial risks such as burial expenses, paying off debts, loss of family income and business profits.

You also may want your life insurance policy to pay estate taxes or to set up a college fund for your children.

Over the years, life insurance policies have evolved from fairly straightforward contracts that provided one type of benefit into complex contracts that often include numerous types of benefits and features. New products have frequently been introduced in response to changing economic conditions and consumer preferences, and that trend is expected to continue in the future.

> If you don't have dependents, you probably don't need life insurance. But if you have dependents—a spouse, children, elderly parents—that rely on your income, you probably need to consider life insurance to pay expenses for them. You also may consider insuring the life of a spouse who is not earning money. That's because the spouse may be helping with family expenses by caring for children instead of putting them in child care.

Today, individual life insurance represents the greatest percentage of in-force business in the United States. It may be characterized as life insurance issued for **face amounts** of at least $1,000 (the face amount is what's paid when an insured person dies).

Life insurance is the only financial services product which guarantees that **a specific sum of money** will

be available at exactly the time that it is needed. Bank savings accounts, mutual funds, stocks, bonds and other investments do not make such a guarantee.

Since the face amount of the policy is payable upon the death of the insured person, the element of risk to the insurance company is much different than it is for an automobile policy. When an insurance company issues an auto policy it hopes that the insured will be a safe driver and will never have an accident. When an insurance company issues a life policy, it knows it will someday be called upon to pay a claim because every human being dies. For the insurer, the only unknown is whether the claim will be made in one year...or in 50.

The term **ordinary insurance** is sometimes used to describe individual insurance. There are three broad types of individual or ordinary life insurance—whole life, term life, and endowment policies.

Life insurance costs vary based on your age, health habits and the amount of insurance.

A life insurance policy may offer a larger benefit when the death of an insured person is accidental. When twice the face amount of the policy is paid upon death occurring accidentally, such coverage popularly is known as **double indemnity**. However, as anyone who's ever read a detective novel can attest, an accidental death is sometimes hard to determine.

THE GENERAL RULES OF LIFE INSURANCE

An insurance policy is a legal contract. The validity of life insurance policies as such has been established in the United States since 1815. As does any contract, a policy contains provisions setting forth the rights and duties of parties to the contract.

> While it is necessary to look beyond the actual wording of the policy contract and into the statutes and court decisions for a full interpretation of policy provisions, they are the basis of the agreement between the company and the policyholder (and the beneficiaries, heirs, and assignees of the policyholder).

There are **no standard policies** in life insurance—as there are in the property and casualty insurance field. However, many states have provisions that are required in all life policies so that some provisions have become more or less standard.

DIFFERENT TYPES OF COVERAGE

Life insurance comes in several varieties.

Term life insurance provides protection for a specified and limited period of time, typically from one to 20 years. Term life is temporary insurance that essentially provides a death benefit only. The benefit is paid only if the insured dies before the end of the specified

term. If the insured person lives beyond the end of the term coverage, the policy simply expires.

> A term policy does not build any cash, loan, or surrender values.

Since term insurance does not build cash values, an insured only has to pay for the death benefit and policy expenses. For this reason, it is usually the least expensive form of life insurance. It may be used as an inexpensive tool to satisfy a variety of temporary insurance needs, such as a mortgage obligation or the need to protect insurability until an insured can afford permanent protection.

There are different types of term policies. **Level term** provides a consistent amount of insurance. **Decreasing term,** which is a good type of insurance to cover a shrinking debt obligation (like a mortgage), starts with a specified face amount which decreases annually until it reaches zero at policy expiration. **Increasing term** provides a growing amount of insurance, but the need for this type of protection is rare.

Some term policies are **renewable,** though. You don't need to provide evidence of insurability to renew the policy; but, each time you renew, the premiums will be higher because you are older and more likely to die.

> **A caveat:** By the time an insured person reaches 70 or 80 years of age, the premiums for a term policy usually approach the face amount of insurance, because the insurance company figures the person is going to die soon.

Many term policies are also **convertible**, which means they may be exchanged for another type of life insurance.

Whole life insurance, sometimes called straight life or permanent life, is protection that can be kept as long as you live. With this kind of insurance, you can choose to pay a premium that doesn't rise as you grow older, averaging the cost of the policy over your life.

Whole life insurance has a **cash value** or the sum that grows over the years with taxes deferred. If you cancel the policy, you receive a lump sum equal to this amount (and you pay taxes only if the cash value plus any dividends exceeds the sum of premiums paid).

The face amount in a whole life policy is constant, and this amount is paid if the insured person dies at any time while the policy is in effect. The policy is designed to **mature** when the insured person reaches 100 years of age. At this point, payments end and the policy's cash value equals the face amount.

> At maturity, the face amount of a whole life policy is usually paid—even if the insured person is still living.

Although whole life policies are among the most common forms of life insurance sold, most individuals do not plan on paying premiums until age 100. More commonly, whole life insurance is used as a form of **level protection** during the income producing years. At retirement, many people then begin to use the accumulated cash value to supplement their retirement income.

This type of life insurance plays an important role in financial planning for many families. In addition to the death benefit or eventual return of cash value, the policy has some other significant features. During a financial emergency, **policy loans** may be taken and the full policy values may later be restored.

Ordinary policies may be **participating** (par) or **nonparticipating** (non-par). A participating policy is one in which the policyholders share in dividends (if a dividend is declared). A nonparticipating insurer does not pay dividends to policyholders.

> Par policies are issued by mutual life insurance companies. Non-par policies are issued by stock life insurance companies.

Many people use dividends to buy additional amounts of insurance instead of taking the dividends in cash. This is really no different than taking a few extra dollars out of your pocket and making a separate purchase. Still, dividends are often **a successful sales tool**, because some people like the idea of getting something extra back—even though they've usually paid more initially.

Universal life insurance is protection under which a policyholder may pay premiums at any time, in virtually any amount, subject to minimums. The amount of the cash value reflects the interest earned and premiums paid, minus the cost of the insurance and expense charges.

> Universal life policies seek to compete in the term insurance marketplace. They offer standard rates that can be substantially cheaper—as much as 30 percent or more—than standard rates charged by term insurers for comparable coverage.

Some universal life policies feature **progressive underwriting**, which is meant to attract otherwise uninsurable consumers. These policies are usually structured so that if policyholders pay the level minimum annual premiums, coverage won't lapse for 15 or 20 years.

Progressive underwriting means companies are aggressive in determining a person's true risk. Instead

of evaluating risk on a by-the-book basis, they pursue questions to find out what's causing any abnormalities in a person's claims history.

Variable universal life insurance provides death benefits and cash values that vary according to the investment returns of stock and bond funds managed by the life insurance company. These policies also allow the policyholder significant discretion in the premiums paid each year.

> For many people, variable universal life is as much an investment tool as a true insurance tool.

In some cases, the cost basis of variable universal life becomes too uncertain because of the **open-ended method of premium payment**. There's trouble if the insurer can't project costs. Target premiums are fixed in the first year but policyholders, because of the flexible nature of the products, are not contractually bound to pay those amounts in subsequent years.

In fact, **target premiums** for this kind of insurance are among the highest in the industry. This is why agents sell variable universal so aggressively—because their commissions are often based on target premiums, they can make more selling this than other kinds of life insurance.

SOME HISTORY...AND SOME CONTEXT

(Although the first policy of life insurance on record was issued in 1563, all policies issued for the next 200 years were either term or endowment.) The few whole life policies issued were for undetermined face amounts.

The formula for a policy issued for the whole of life on a level premium basis eluded mathematicians until 1762. In that year, the Society for the Equitable Assurance of Lives and Survivorships (today commonly referred to as *Old Equitable* and one of Britain's leading life insurance companies) came out with a whole-life, level-premium, fixed-amount policy.

The first day the policy is in force, the insured person has $100,000 of protection. If the insured should die one week, one month, one year, 10 years, or 50 years later his beneficiaries would be paid $100,000. The face amount of the policy remains the same throughout the life of the policy—and the insured.

Death benefits are the one thing that all types of life insurance contracts have in common. Any contract that did not pay a death benefit could hardly be called *life insurance*. The product gets its name from the fact that a life is being insured, and it is the loss of life that triggers payment of the benefit. Death benefits represent the true insurance element, the pure protection aspect, of all life insurance policies.

You could argue that anyone who knew for certain he or she would live to an old age would be foolish to

spend money on life insurance. The premiums could be put to better use over the course of a long life—and it would only be necessary to set aside a small sum for the eventual funeral.

But none of us can be certain that we will live for a long time—even if ancestors are long-lived. There is always the possibility that a disease or accident will end things prematurely. Anyone can become a victim of a natural disaster or an act of violence.

The need to cover expenses and replace lost family income if early death occurs may be the main reason why people purchase pure life insurance protection, but it is not the only reason people purchase life insurance products.

Originally, life insurance contracts only provided death benefits. That has changed. Today, many forms of life insurance include other types of benefits, and people also buy life insurance to protect against the risk of *not* dying prematurely—to protect against the risk of living for a long time.

MORE THAN JUST DEATH BENEFITS

The many uses of life insurance today extend far beyond the original concept of a death benefit. Certainly death benefits continue to play a major role in life insurance sales presentations and purchase decisions, and that will always be true.

It is worth pointing out that many transactions that may add to family finances and security may be backed

up by life insurance. When a person borrows money for a real estate purchase, an investment opportunity or starting a small business, the funds may not be available unless life insurance on the **life of the borrower** is purchased to protect the interests of the lender. Use of life insurance in this manner may in the long run help an individual to build personal assets and advance family security.

In addition to death benefits, many life insurance policies include other features, such as savings or investments. This makes it possible to use life insurance as a vehicle for **building capital**—for accumulating assets or funds designed to serve specific purposes. Thus, some people use life insurance to accumulate funds for children's education, to provide retirement income, to create or add to an estate and for other purposes.

Many people question whether life insurance is the best method of getting access to capital. But there's not much question that it's one of the safest and most conservative methods.

In addition to death benefits, many life insurance contracts include other types of insurance benefits. These non-life insurance benefits may be included in a policy or may be attached as optional **riders**.

One of the most commonly found types of additional benefit is known as **waiver of premium**. This is actually a disability insurance benefit, which pays the life insurance premiums while an insured person is disabled.

Another type of disability benefit that is commonly attached to life insurance policies is a **disability income** benefit. This usually is provided as "waiver of premium with disability income," but it may be attached as a separate benefit. A disability income benefit pays a monthly income to an insured person who is totally disabled.

Dismemberment benefits may be attached to a life insurance policy, most frequently in the form of **accidental death and dismemberment** benefits.

As we've seen, the accidental death benefit pays an additional death benefit if an insured person dies because of an accident. The dismemberment benefit pays specified sums if the insured loses one or more limbs, or sight of one or both eyes, and in some cases hearing, as the result of an accidental injury. Since the insured person is still alive and this is not a death benefit, it is not—technically—a form of life insurance.

In recent years, the concepts of **living or accelerated benefits** and **long-term care** needs have begun to take hold in the life insurance field. They are increasingly showing up as benefits attached to life insurance contracts.

In the case of living benefits, a portion of the proceeds that would otherwise be payable as **a death benefit is advanced** to an insured who has a terminal disease

and a need for special medical care. It is widely acknowledged that this is a humane application of life insurance proceeds, because the funds are often used to ease pain, suffering and discomfort during the final period of life.

> These benefits are usually provided without charge because the payment of a death claim is imminent.

Long-term care benefits pay for **nursing care, home health care, or custodial care** (assistance with the tasks of daily living, such as eating, bathing, dressing, etc.) which may be needed following a period of hospitalization. This is actually a health insurance benefit which is often sold separately as part of a health insurance policy. However, it is often available as a rider to a life insurance policy.

> When sold as a separate benefit, an additional premium is charged and the benefit will not affect the policy's face value of cash value. When sold as part of an integrated plan, an additional premium is not charged for long-term care benefits which are simply borrowed from the life insurance benefits—and accordingly reduce the remaining face value and cash value.

WHO'S INVOLVED IN A LIFE INSURANCE CONTRACT

When a life insurance policy is issued, a number of **parties** may be involved with respect to contract obligations and benefits. Obviously, the insurance company is a party to the contract—in exchange for the premium payment, it has agreed to pay certain benefits if the insured dies.

Since the insurance will pay a benefit if the insured person dies, it is also obvious that this person is a party to the contract. But there may be other parties. To identify these parties, we need to consider who owns the policy, whose life is insured, and who is entitled to the benefits. In the life insurance business, these parties may differ depending upon how the policy is issued and what rights are exercised.

The **insured** is the person whose life is insured. A death benefit will be paid if this person dies while the insurance is in effect.

The **owner of a policy** is the person who applies for the insurance, agrees to pay the premiums, and has certain ownership rights. Generally, the policy owner has the right to elect or change the beneficiary, to elect settlement options, and to assign ownership to another person.

A **beneficiary** is someone who is entitled to death benefits if the insured person dies. There may be one or more designated beneficiaries. There may be **primary beneficiaries** who are entitled to the proceeds if they are living, and **contingent beneficiaries** who are en-

titled to the proceeds if there is no surviving primary beneficiary when an insured dies.

> Example: George buys life insurance on his own life and directs that the proceeds be paid to his estate. George is the owner. George is the insured. George's estate is the beneficiary.

The owner of a policy may or may not be the insured person, and may or may not be the beneficiary. The same person cannot be both the insured and the beneficiary, but the insured's estate may be the beneficiary.

> Example: Sally buys life insurance on her husband's life, Jim, and names herself as beneficiary. In this case, Sally is both the owner and the beneficiary. Jim is the insured.

> Another example: Sally's father, Ralph, buys separate life insurance policies on the lives of Sally and Jim and names their children (his grandchildren), Carol and Mike, as the beneficiaries. Ralph is the owner. Sally and Jim are insureds. Carol and Mike are the beneficiaries.

The owner of a life insurance policy is entitled to certain valuable rights. These include the **right to assign or transfer** the policy, and the right to select and change the payment schedule, beneficiary and settlement option.

The owner also has the **right to receive cash values** or dividends and the **right to borrow** from the cash values.

INSURABLE INTEREST

You can't purchase life insurance on the lives of anybody you want. In order to purchase life insurance, you must have a legitimate **insurable interest** in the subject of the insurance. There must be a personal risk of emotional or financial loss, and a legitimate interest in preserving and protecting the life being insured.

> Without a requirement for insurable interest, people might gamble on the lives of total strangers, particularly those who engage in high-risk activities. Additionally, the absence of insurable interest might actually put lives in danger—a person might act to cause another person's death or fail to exercise reasonable safety precautions to protect someone else if they had no personal risk of loss and stood to gain financially from the death.

Every person is presumed to have an insurable interest in his or her own life. However, this interest is not necessarily unlimited. If the amount of insurance applied for is **disproportionate to a person's apparent needs**, it will raise underwriting concerns on the part of the insurance company.

> Example: Dave, who has an annual income of $25,000 and very few assets, applies for $5 million of life insurance. Dave's economic status would not seem to justify such a large need for insurance, and his income is inadequate to pay the required premiums. Upon investigation, the insurance company discovers that Dave has numerous outstanding gambling debts and other financial problems. He also has a wife and three children. This application would probably be turned down because of the extreme risk that Dave may be planning to stage his own death.

You also have an insurable interest in the lives of close relatives through blood or marriage. Usually this extends to those who could be considered **immediate family members**—such as your spouse, children, parents, and perhaps brothers and sisters. The requirement for insurable interest becomes more difficult to justify when insurance is sought on the lives of more

distant relatives, such as uncles, aunts, nephews, nieces, and cousins, but insurable interest certainly may exist in these cases—especially when such relatives live in the same **household**.

Insurable interest may also be established on the basis of **business and financial relationships**. Members of a partnership have an insurable interest in the lives of other partners. Lenders have an insurable interest in the lives of borrowers to the extent of the funds at risk. Any commercial enterprise, ranging from corporations to movie studios and professional sort organizations, may have insurable interests in the lives of individuals who make significant contributions to sales and profits.

> **In the life insurance business, insurable interest must exist at the time of application and inception of the policy and not necessarily at the time of death.**

If a policy is valid when it is issued, the death benefit is payable even if insurable interest no longer exists at the time of the insured's death. The requirement for insurable interest applies only to the owner of a policy. There is a greater flexibility allowed when it comes to the proposed insured's selection of a beneficiary.

Example: Roseanne purchased life insurance covering Tom, naming herself as beneficiary, when they were married. They never had children and divorced a few years later. Both remarried. Many years passed by, during which Roseanne and Tom had no communication with each other—but Roseanne continued paying premiums to keep Tom's life insurance in force. When Tom died and Roseanne read about it in the paper, she submitted a claim. The claim is valid because Roseanne had an insurable interest when she originally bought the policy.

In real life situations, people don't usually continue to pay life insurance premiums after an insurable interest has ended. When insurable interest no longer exists, ownership of a policy may be transferred or assigned to the insured, to the insured's new spouse, to children, or to someone else who has a more current insurable relationship with the insured.

THE LIFE INSURANCE APPLICATION

In completing a life insurance application, you will usually be asked to provide some **general information**, including: your full name, address, phone number, social security number and billing address. You may also be asked to provide some more **specific information**, including: hobbies and whether or not they are considered dangerous (a hint: scuba diving, hang gliding, flying small aircraft and bungee jumping are) and medical history (if you've been previously declined or rated for life insurance).

In most cases you are also asked to take a **physical examination,** paid for by the company to which you are applying. All of this information is needed for the insurance company's **underwriting process.**

The insurance company wants to know exactly what type of risk you might be. It assesses all of your information concurrently to make a well informed decision. The risk it sees within the obtained information is all taken into consideration when the company makes a decision to offer you coverage or decline your request.

You may end up somewhere between insurable and not insurable. If so, the insurance company may offer you a **rated policy** for which you must pay a higher premium.

> By signing the application, you are not committing to buy insurance, you are requesting that the insurance company review your information and offer you coverage. Some hard-sell agents or companies may try to tell you that you have to accept the coverage offered. This is virtually never true. Insurance is not in force until premiums are paid.

At the time you complete the application, you sign and date it to confirm that all the information you have given is true to the best of your knowledge. Most companies have a clause regarding misstated information or a **fraudulence clause.** This gives the com-

pany the right to review its decision if you have pro-
vided false information or omitted information.

The **contestability period**—which usually lasts for
two years—is the time within which an insurer may
deny a claim based on information you have stated in
the application. After this period, the policy becomes
incontestable and the insurer may not deny a claim
even if fraudulent or concealed information is discov-
ered. The insurer may then deny a claim only on the
ground that an insurable interest was not present be-
tween the insured and owner at the time of applica-
tion.

Upon receiving your policy, make sure you review the
type of plan, owner, beneficiary, premium, face amount
and schedule of future premiums thoroughly before
accepting it. Be sure you understand the **exclusions**,
length of time the policy will be in force and optional
values. If you use an agent, he or she will usually pro-
vide a **summary page** that minimizes any confusion.

Be sure you understand what rights the company has
to make changes and what assumptions were used.

If you receive a rated (or classified) policy you may
want to try other carriers for alternative rates since
underwriting standards vary from company to com-
pany.

Even if you've paid the first premium, you can refuse
to accept a policy for **10 days after receiving it** and
still get a full refund.

CONCLUSION

As we approach the end of the twentieth century, the increase in efficiencies created by telecommunications is spawning a wave of mergers and **consolidations in the financial services industry**. It is reasonable to expect that insurance companies will be consolidated and the smaller companies will be bought out—and the policies a person holds may be managed by new entities.

What does that mean for you as the consumer? Depending on the type of policy you have, does the company have the right to raise its administrative expenses arbitrarily? One often-voiced concern is that if a large company acquires a smaller company, the larger company may raise **internal charges** to the policy in order to generate more revenues and to pay off the debt service of the acquisition.

While no one knows what the future will bring to the insurance industry over the next 10 or 20 years, it makes sense to consider **the size and profitability** of the insurance company as important factors in your selection process.

Beyond this issue, the basics of life insurance are pretty simple.

The primary purpose of life insurance is to pay a death benefit, and a **death benefit** is the one feature that all forms of life insurance share in common. Death benefits are usually purchased and used to cover final expenses, pay outstanding debts, and provide income and security for survivors.

In addition to providing protection against premature death, life insurance attempts to protect against the risk of not dying early. Many life insurance contracts include **cash values** or **savings features** which make it possible to accumulate funds for education, retirement income, and other purposes.

Life insurance products have evolved in response to changing **economic conditions** and **consumer preferences**. All life insurance policies include some form of true life insurance protection. Many policies also include other types of insurance benefits and non-insurance elements.

Various parties may be involved in any life insurance contract. There is always a **policy owner** and **an insured person**. There may or may not be a designated **beneficiary**. An owner may also be the insured or the beneficiary. In some cases, the owner, insured and beneficiary are all different individuals.

In order to purchase life insurance, an applicant must have an **insurable interest** in the life of the person to be insured. This insurable interest must exist at the time the policy is issued, but need not exist at the time of the insured's death.

In the next chapter, we will look at what to do after you have decided whether or not you need life insurance. We will look at how to calculate the amount and type of life insurance that you need to purchase.

CHAPTER 2

HOW TO FIGURE OUT HOW MUCH LIFE INSURANCE YOU NEED

INTRODUCTION

Only 43 percent of American adults own individual life insurance—and the average American adult has just $45,000 of life insurance. Relying on the group life insurance provided at work can build a **false sense of security**, since coverage is usually insufficient for family needs and coverage generally ceases when employment terminates. Most financial planning experts agree that few people protect their own full value with life insurance, leaving their families at risk.

BENEFITS OF LIFE INSURANCE

The death of an insured person creates an **instant estate** for the benefit of the individual's family. From a personal perspective, life insurance may be used to provide peace of mind and financial security for a family.

But you are probably more interested in figuring out what you *need* rather than what you *want*.

When a person dies, he or she typically leaves behind the **unfinished business** of a lifetime. This is particularly true of individuals who die earlier than normal life expectancy would predict. Costs associated with death include:

- doctor and hospital bills from a final illness or accident,

- funeral expenses,

- estate taxes, and

- other debts (credit cards, consumer loans, etc.).

In addition, to people leaving behind a family or other dependents financially dependent on them for support, the following **financial needs** will immediately become apparent:

- mortgage payments;

- immediate income needs—to pay for groceries, utilities, car payments, and other day-to-day living expenses; and

- long term needs—money to pay for children's educations, retirement income for a spouse.

People in the insurance industry call the process of calculating a person's insurance requirements **needs analysis**. This needs analysis is often accomplished by identifying the specific **financial objectives** of the individual by means of a fact-finding interview.

In this interview, an insurance salesperson visits you—or talks with you on the phone—and asks about your circumstances and goals.

After the needs analysis is complete, the salesperson makes recommendations as to the amount and type of insurance you need. These recommendations should consider the following:

- Should the coverage be permanent or term insurance—or a combination of the two?

- How much premium can the individual afford to pay?

- Should the premium be level, increasing or decreasing?

- Is the individual insurable?

A HUMAN LIFE—WHAT'S IT WORTH?

The **human life value** concept was developed in the 1920s by Dr. S.S. Huebner. His concept was based on the fact that when a working person dies his or her ability to produce income or support a family is lost. Huebner realized that value cannot be placed on a human life the way it is on a piece of machinery. So the value was placed, not on the life itself (as the name of the concept may imply) but on the **earning potential** of the insured person, calculated and projected over a period of years.

In formulating the items to determine need, Huebner looked at four general areas:

- the individual's net annual salary,

- the individual's annual expenses,

- the number of years the individual has left to work (the present to retirement age), and

- the value of the individual's dollar as it depreciates over time.

The human life value concept was a way of determining what a family would lose in income by the death of the principal wage earner. By this method, if the insured died, the family could be reimbursed for that loss.

The issue of what a life is worth is one that claimants and insurance companies usually end up fighting over in court.

- A 28-year old construction worker earning $35,000 per year was training to become an engineer. At a trial, after his accidental death, an economist testified that the economic loss to his family was $1.6 million. The court awarded $2.5 million for economic loss, which was held up on appeal.

- A 37-year old maintenance worker was earning $160 per week before he died. At

trial, an economist testified that the economic loss to his family was $341,591. The appeals court agreed.

- A 44-year old truck driver earned $24,000 per year and was attending classes to qualify for a management position before he was killed in an accident. A court awarded $1.22 million for loss of financial support and services to his family.

How do courts come up with these figures? They consider not just what an insured person earns today but also what he or she may earn in the future—accounting for inflation, pensions, retirement benefits, etc.

In addition to economic factors, a court may consider personal and family factors—such as:

- children's school performance and socialization skills after they experience the death of a parent,

- the effect on a family of a surviving parent having to work full time,

- financial stress and/or job pressures that follow from the death of an income-earning parent or spouse, and

- emotional impacts of grieving and coming to terms with the unexpected loss of a family member.

Although money can't replace a deceased family member, courts will often decide that money offsets the impact of the death on a family's opportunities.

CONSIDERING OTHER SOURCES OF PROTECTION

In determining the amount and kind of insurance you need, you should consider **other sources of income** or benefits you currently have—or for which you may be eligible under other insurance plans, government programs (such as Social Security), and retirement plans (pensions, IRAs, Keogh accounts, etc.).

Some other sources of funds to be considered are:

- Medicare,
- Medicaid,
- group retirement plans,
- savings,
- investments,
- other income (from property rental, etc.),
- annuities, and
- other insurance.

These other assets will help in determining the amount, and kind, of insurance necessary to meet your current and future needs.

There is a period of time, often called the **blackout period**, after a surviving spouse no longer receives survivor's benefits (after her youngest child is no

longer eligible) and before she is eligible for retirement benefits.

For example, Social Security benefits may not pay the retirement benefit a dependent spouse needs prior to age 65.

PLANNING MONEY—LONG TERM

Most people think about money in the short term: annual salary, cost of a car, cost of taxes, price of housing.

But there are **long-term money issues** to consider when planning for your family's well-being. How much money will you make between now and retirement? What will you need to retire, factoring in inflation? How long does a set amount of money—even a million dollars—last?

These questions apply even more directly to a family's needs if the **breadwinner dies prematurely**.

The following charts show:

- how much you need to put away to accumulate $1,000,000;
- how long $1,000,000 will last; and
- the impact of inflation on a set amount of money.

The charts allow you to calculate how much insurance your family will need.

EARNING POTENTIAL CHART

To Age 65

		What Are You Worth?		
Age	$25,000 Yearly Income	$50,000 Yearly Income	$100,000 Yearly Income	$150,000 Yearly Income
20	1,125,000	1,800,000	4,500,000	6,750,000
21	1,100,000	1,760,000	4,400,000	6,600,000
22	1,075,000	1,720,000	4,300,000	6,450,000
23	1,050,000	1,680,000	4,200,000	6,300,000
24	1,025,000	1,640,000	4,000,000	6,150,000
25	1,000,000	1,600,000	4,000,000	6,000,000
26	975,000	1,560,000	3,900,000	5,850,000
27	950,000	1,520,000	3,800,000	5,700,000
28	925,000	1,480,000	3,700,000	5,550,000
29	900,000	1,440,000	3,600,000	5,400,000
30	875,000	1,400,000	3,500,000	5,250,000
31	850,000	1,360,000	3,400,000	5,100,000
32	825,000	1,320,000	3,300,000	4,950,000
33	800,000	1,280,000	3,200,000	4,800,000
34	775,000	1,240,000	3,100,000	4,650,000
35	750,000	1,200,000	3,000,000	4,500,000
36	725,000	1,160,000	2,900,000	4,350,000
37	700,000	1,120,000	2,800,000	4,200,000
38	675,000	1,080,000	2,700,000	4,050,000
39	650,000	1,040,000	2,600,000	3,900,000
40	625,000	1,000,000	2,500,000	3,750,000
41	600,000	960,000	2,400,000	3,600,000
42	575,000	920,000	2,300,000	3,450,000
43	550,000	880,000	2,200,000	3,300,000
44	525,000	840,000	2,100,000	3,150,000

This chart is **not adjusted for inflation** or salary increases. Including inflation or salary increases will result in multiplying the value numbers 2 to 4 times.

How much money does your family need—invested at 6 percent—to guarantee its current monthly income?

Investable Assets	Rate of Return	Pre-Tax Annual Income	Tax Burden
200,000	@ 6 %	14,000	1,000
400,000	@ 6 %	24,000	2,000
600,000	@ 6 %	36,000	3,000
800,000	@ 6 %	48,000	4,000
1,000,000	@ 6 %	60,000	5,000
1,200,000	@ 6 %	72,000	6,000
1,400,000	@ 6 %	84,000	7,000
2,000,000	@ 6 %	120,000	10,000

WHAT IS YOUR "MONTHLY NUT"

While there are software programs for calculating **base income needs**, most families have an instinctual understanding of the so-called "monthly nut" that is required to maintain their lifestyle.

Typically, the base income need is 60 to 70 percent of current income. In some cases, it is more.

If it is easier for you to think in terms of a dollar-value of monthly income needs, use this formula:

The amount needed to generate income at 6%

Monthly Income Needed: $_____ x 200 = ?

For example, if your family needs $3,000 per month, then multiply $3,000 x 200 = $600,000. As you can see, $600,000 invested at 6 percent will yield $36,000 per year—that is, $3,000 per month.

During the early 1990s, **inflation** remained relatively low. However, inflation did average **3 percent per year** between 1945 and 1995.

We know that $36,000 in the future won't buy as much as it does today. In fact, the impact of inflation is devastating. The following chart shows what $36,000 is worth in the future—expressed in today's dollars.

Inflation	Today	10 Years	20 Years	30 Years	40 Years
0%	36,000	36,000	36,000	36,000	36,000
4%	36,000	51,239	75,847	112,271	166,189
6%	36,000	60,821	108,922	195,062	349,326

This means your family will need $75,847 per year in twenty years to equal $36,000 in today's purchasing power at an inflation rate of 4 percent.

THE BUDGET WORKSHEET

The following chart outlines expense calculations for the budget items essential to most families.

TYPICAL FAMILY GOALS:

1. Guarantee a safe home in the neighborhood
 you want for your children (amount of mort-
 gage or home purchase). $ _____

2. Have an emergency fund of 3 - 6 months
 income that is "untouchable" except for
 emergencies. $_____

3. Pay-off current debts, credit cards, back
 taxes, medical bills, personal debts, final
 expenses. $_____

4. Set aside a college fund based on $15,000
 to $25,000 per year of school to be
 covered. $_____

INCOME REPLACEMENT CALCULATION:

5. If the mortgage is paid, there are no
 current debts, what is the monthly
 income after tax required to take
 care of the family? $_____

6. Amount of capital required to generate
 the monthly after tax income assuming
 6% after tax return. $_____

Example: $36,000 per year = $3,000 per
 month
 $3,000 x $200 = $600,000
 $600,000 x 6% = $36,000 per year

ADD 1, 2, 3, 4, and 6 for total liquidity required:
 $_____

From your total liquidity required subtract the following:

Current cash	$_____
Stocks, bonds, etc.	$_____
Real estate to be sold	$_____
Assets to be sold	$_____
Existing life insurance	$_____
Sub-Total	$_____
Liquidity required	
Less existing life insurance	$_____

TOTAL ADDITIONAL INSURANCE REQUIRED = $_____

BUDGET METHOD WORKSHEET

1. Pay off mortgage or purchase home $_____

2. Emergency fund $_____

3. Pay current debts, credit cards, taxes, auto, final expenses $_____

4. College fund at $15,000 - $25,000 per year of schooling $_____

TOTAL $_____

Income replacement monthly after tax income
$_____ × 200 = $_____

Total resources needed $_____
Subtract resources:

Current cash	$_____
Stocks, bonds, etc.	$_____

Real estate to be sold	$_____
Assets to be sold	$_____
Existing life insurance	$_____
Sub-Total	$_____
TOTAL	$_____

TYPICAL FAMILY GOALS

1. Remain in the same home, neighborhood, schools.

2. Pay off mortgage.

3. Provide an emergency fund.

4. Pay off current small debts.

5. Set aside a college fund for each child.

6. Replace some of all of the lost income resulting from the death.

FUTURE COLLEGE COSTS

How much will a college education cost at some point in the future? The following chart offers some insight.

Age of Child Now	Years to College	Annual Cost*	Four Year Cost**	Annual Investment Required at 8%
18	0	10,000	40,000	40,000
17	1	10,800	43,200	40,000
16	2	11,664	46,656	20,769
15	3	12,597	50,388	14,371
14	4	13,605	54,420	11,182
13	5	14,693	58,772	9,276
12	6	15,869	63,476	8,012
11	7	17,138	68,552	7,145
10	8	18,509	74,036	6,445
9	9	19,990	79,960	5,929
8	10	21,589	86,356	5,520
7	11	23,316	93,264	5,188
6	12	25,182	100,728	4,915
5	13	27,196	108,784	4,686
4	14	29,372	117,488	4,492
3	15	31,722	126,888	4,327
2	16	34,259	137,036	4,184
1	17	37,000	148,000	4,060
0	18	39,960	159,840	3,952

*Adjusted for 8% cost increase annually.
**This is cost discounted at 8%.

Example: If your child is now 8 years old, what now costs $10,000 will cost over $21,000. To accumulate the four-year cost, which will exceed $86,000, you will need to invest $5,520 annually at 8 percent. If the cost today were $20,000, as opposed to $10,000, you would need to invest twice as much starting now—$11,040 each year.

NAMING AND MAINTAINING BENEFICIARIES

An important part of determining how much life insurance you need is determining **to whom you'll leave the money.** Some insurance agents consider this a separate function—but that's a mistake. You should consider it part of the same process.

> The beneficiary provisions of most life insurance contracts allow the insured or the policy owner to direct the payment to any person he or she chooses.

A variety of different parties may be designated as beneficiaries under the life insurance policy. The beneficiary can be a **person or institution,** such as a foundation or charity. A specifically designated person, more than one person, or a class or classes of persons may be named as beneficiaries. You can also name your estate, a trust, or any other legal entity as a beneficiary.

Almost all life insurance beneficiary designations are **revocable** or changeable. Usually the insured person

retains the right to change the beneficiary, unless he or she has specifically given up that right.

It is possible, however, for the owner of the policy to give up the right to change the beneficiary designation at will. In such cases there is an **irrevocable** beneficiary and the designation cannot be changed without the consent of the beneficiary.

An irrevocable designation might be used when a court orders a husband in a divorce settlement to continue payment on an insurance policy on his own life, with an irrevocable beneficiary designation on behalf of his wife (the primary beneficiary) and his children (the contingent beneficiaries).

In the event that the irrevocable beneficiary dies before the insured, the right to select the beneficiary may revert to the policy owner on a **reversionary** basis.

It is customary in life insurance contracts to specify a **primary** and a **contingent** beneficiary (or beneficiaries). The primary beneficiary has first claim to the proceeds of the life insurance policy following the death of the insured. If the primary beneficiary dies before the insured, however, the contingent beneficiary is entitled to the benefits of the life insurance policy.

If the primary beneficiary dies before the insured person and there is no contingent beneficiary, the estate of the insured becomes the beneficiary—and is subject to the claims of unsecured creditors.

In a family situation, a common primary and contingent designation is as follows: *Mary Jane Smith, wife, as primary beneficiary and as contingent beneficiaries all children, adopted or born of this marriage, to share equally.*

After the death of the insured, the proceeds belong to the beneficiary. If a **lump sum benefit** is paid, the insurance company has no further obligation to the beneficiary. If an option other than a lump sum payment is selected, or an arrangement is made where **benefits continue** over a period of time, the beneficiary should name his or her own beneficiary.

Careless wording of beneficiary designations can result in undesirable consequences. A tremendous amount of time is spent each year in courtroom litigation attempting to determine beneficiaries and heirs. It is important that you designate the beneficiary by full name to avoid misunderstanding.

> If an insured person designates his *wife* as the beneficiary, confusion may arise. If the insured has married more than once, does *wife* mean his present wife or does it mean his wife at the time the policy was written? Or does it apply to another ex-wife who is now caring for his minor children?

The insurance company will make every effort to **distribute the proceeds** of a policy in compliance with the wishes of the insured person—as long as the insured makes it clear what his or her intention is.

When the intention is not clear, the company must distribute the funds according to the **apparent intent** of the insured, or pay the funds to a local court and request a judicial determination of the proper distribution.

Naming children who are **minors as beneficiaries** may be easiest for you when completing your insurance application. But consider the practicability of a six-year-old receiving $100,000—and not even knowing what a bank is.

CLASS DESIGNATION

In naming children as beneficiaries, a **class designation** is sometimes desirable. Class designations should be used when individuals of a specific group (such as children of the insured person) are to share the policy proceeds equally.

If an insured person designates his children as beneficiaries by naming each child specifically, other children might be excluded from sharing in the proceeds of the policy. This might occur if the insured failed to update his beneficiary provision in his policy to include children who were born, adopted or otherwise joined the family since the date that the policy was purchased.

The **wording of the class designation** must carefully specify your intention. A designation of *my children* might include children of previous marriages or relationships—when, in fact, you might prefer to exclude them. An even more complex scenario: Naming *my children* as beneficiaries would allow children living at the time of your death to share in the proceeds; but a child born after your death would not be entitled to receive a portion.

By using your spouse's full name followed by the designation *my wife* or *my husband*, fewer questions can arise about your intent.

If an insured person wants to restrict the designation to the children of his present marriage, he might designate his present spouse *Carolyn Jones Bennett* as primary beneficiary and use the term *our children* or *children born of this marriage* as contingent beneficiaries.

In addition to the class designation, the **per capita** and **per stirpes** designations are used to benefit children. The per capita designation means *by heads* (individual) and per stirpes means *by stock* (family line or branch).

Under a per capita designation, each surviving child shares equally in the death benefit. Under a per stirpes designation each child, grandchild, or great grandchild, etc., moves up in a representative place of a deceased beneficiary.

A per stirpes designation can become quite involved. It is important to know how the **line of representation** works because of the manner in which courts interpret the per stirpes designation. The majority of courts hold that each family member can move up to represent the closest older relative (usually his or her parent).

The following examples should help to clarify the per stirpes designation:

- Example 1. Mrs. Smith has three children, Faith, Hope, and Charity. At her death each child will share equally in the death benefit—one-third each.

- Example 2. If, at Mrs. Smith's death, Faith is no longer living and she has no dependents, Hope and Charity will share the death benefit equally—one-half each.

- Example 3. If, at Mrs. Smith's death Faith is no longer living but she is survived by two children, Jack and Jill (Mrs. Smith's grandchildren); Hope and Charity will each receive one-third of the benefit, and Faith's one-third will be divided equally between Jack and Jill—one-sixth each.

- Example 4. If, at Mrs. Smith's death, Faith (child) and both Jack and Jill (grandchildren) are also deceased, but Jack is survived by two children and Jill is survived by one child (Mrs. Smith's great grandchildren), Jill's child will get one-sixth benefit while one-sixth of the benefit will be divided between Jack's two children—one-twelfth each.

- Example 5. If, of the three great grand-children, one of Jack's children is dead at the time of the distribution and has left two children (Mrs. Smith's great great grandchildren), those two children are only entitled to share Jack's child's one-twelfth—the great grandchildren receive one-twenty-fourth each.

Although the preceding examples represent the majority finding, some courts have held that, for example, a grandchild can move up and share in the benefits on the same percentage basis as the original children.

SPENDTHRIFT CLAUSE

One of the most appealing features of life insurance is that the proceeds are **exempt from the claims of your creditors** as long as there is a named beneficiary

other than your estate. A similar provision with reference to the beneficiary is the **spendthrift clause**.

The spendthrift clause is designed to protect the beneficiary from losing the life insurance proceeds to creditors, assigning the proceeds to others or spending large sums recklessly. The clause is not applicable to lump sum settlements but is applicable to **installment settlement** options. It only protects the portion of proceeds not yet paid (due, but still held by the insurer) from the claims of creditors to the extent permitted by law.

> You normally select this provision as part of the policy at the time of the application for insurance.

As long as the proceeds are paid on one of several settlement options—whereby the insurer keeps the proceeds and sends a monthly payment to the beneficiary—the amounts received by the beneficiary are exempt from the claims of his or her creditors.

EXCLUSIONS AND LIMITATIONS

The last factor you should consider in figuring out how much insurance you need is what standard policies do and don't cover. Life insurance policies may contain certain **exclusions** or **restrictions**. The main exclusions are:

- **Suicide.** Initially, life insurance contracts excluded the risk of suicide entirely. This

exclusion left dependents without protection, defeating the purpose of purchasing insurance coverage. Also, it was incorrect to exclude suicide completely because death by suicide is included in the mortality tables upon which premiums are based. The majority of life insurance policies issued today contain a time provision restricting liability in the event of suicide. Usually the time limit on the restriction is two years, although occasionally it is only one year or less. A typical provision is that, in the event of suicide within this period, the liability of the company shall be restricted to an amount equal to the total of premiums paid, without interest less any indebtedness.

Accidental death benefit is excluded from suicide coverage, since suicide is not considered an accident.

- **Aviation.** In the past, aviation exclusions were very common. Today, this type of exclusion is rarely found in life insurance policies. Among the types of aviation restrictions still found are these:

 Exclusion of all aviation caused or related deaths except those of fare-paying passengers on regularly scheduled airlines. Some policies do not include the phrase, *regularly scheduled airlines*, thus covering nonscheduled flights also—but only for a fare-paying passenger.

Exclusion of deaths in military aircraft only or death while on military maneuvers.

Exclusion of pilots, crew members, student pilots, and (sometimes) anyone with duties in flight or while descending from an aircraft, e.g., parachuting.

Companies using any or all of these restrictions will afford coverage of civil aviation deaths for an extra premium. The exclusions or restrictions apply only to those unwilling to pay the extra premium required and to military duties.

- **War and Military Service.** In wartime, it has been common for companies to include restrictions which limit the death benefit paid to usually a refund of premium plus interest or possibly an amount equal to the policy's cash value. Often in the past, the policy's benefits were suspended during a war or an act of war. The term, "act of war" has been used to describe the Korean and Vietnam conflicts.

 Today, most insurers will provide some form of life insurance coverage for those on military duty. Traditionally, there are usually two types of restrictions or clauses which may be used. The **status clause** excludes the payment of the death benefit while the insured is serving in the

military. The **results clause** excludes the payment of the death benefit if the insured is killed as a result of war.

- **Hazardous Occupations and Avocations.** By today's underwriting standards, few applicants are declined life insurance because of their **occupations**. For example, firefighters and police personnel can purchase life insurance at standard rates. Even commercial airline pilots can usually purchase life insurance (although possibly at higher than standard rates).

 Much of the underwriting attention is focused on **avocations or hobbies**. If an applicant participates in a hazardous hobby such as auto racing, sky diving, scuba diving, etc., then the amount of insurance which may be purchased may be limited or an extra premium may be charged due to the additional risk. Depending on the hobby, the death benefit may be excluded if death was caused as a result of the hazardous avocation.

PROVISIONS NOT PERMITTED

By law in most states, life insurance policies are not permitted to contain the following provisions:

- A provision that **limits the time for bringing a lawsuit** against the insurance company to less than one year after the reason for the lawsuit occurs.

- A provision that allows a **settlement at**

maturity of less than the face amount plus any dividend additions, less any indebtedness to the company and any premium deductible under the policy.

- A provision that allows **forfeiture of the policy** because of the failure to repay any policy loan or interest on the loan if the total owed is less than the loan value of the policy.

- A provision making the soliciting agent the **agent of the person insured** under the policy or making the acts or representations of the agent binding on the insured. (The agent must only be an agent of the insurance company.)

- The law of the state in which the policy is sold governs the contract. The policy may not contain a provision by which the laws of the **home state of the insurance company** govern the policy provisions.

SPECIAL FAMILY NEEDS

Many people have dependents who are dependent for various reasons. Some middle-aged people want to guarantee that their elderly parents have little extra income support for retirement or long-term care. Also, as we've seen in some of the examples above, children of previous marriages may pose complicated insurance issues. And some people have several children—but one with a disability or handicap who may require a little more financial security than the others.

There are unlimited special situations in which you find you may need to be prepared. The different solu-

tions available are also unlimited. There is no reason you can not designate everything you want to be incorporated within your legal documents.

When you figure the amount of cash that will be available after everything has been sold or liquidated in the appropriate way, you may find that there is a large amount of money available. People who consider themselves middle class will find that—in addition to their life insurance proceeds—there can be hundreds of thousands of dollars in their estates.

Sometimes in planning, people discuss **multiple beneficiaries** and designate insurance proceeds specifically—30 percent to a parent, 50 percent to a spouse, and 20 percent to the children of a previous marriage. Many parents consider it a bad idea to dump a huge pot of cash into the hands of a 21-year-old who has not had the experience necessary to manage it properly. Therefore, many parents arrange the distribution of assets to come at designated ages or situations—by means of a trust.

> While it may be expedient to designate funds specifically, it could be a serious mistake if not handled correctly. It might be a better idea to put money for specific relatives into several trusts. These trusts can designate monthly sums to be distributed and other amounts to be put aside for emergencies. If any money is left when the beneficiary dies, you can designate that it go to other relatives, a charity or wherever else you wish.

TAKING CARE OF MINORS AND SPOUSES

Even after deciding to buy life insurance, most parents really stumble when confronted with the worst case scenario, the tragedy of both parents dying simultaneously:

- Who will the guardians be?

- Who will manage the insurance and other investments after your death?

- How and when should the children receive inheritance without spoiling them, ruining them or controlling them from the grave?

- Who can we trust? Who will make sure they are trustworthy?

> While life insurance is a key part of most family planning, it is only a part. The insurance guarantees liquidity—cash—to help survivors. But there are other critical questions for most people. Insurance needs to be integrated into a total plan.

Issues that most people try to consider when they plan for the future:

- What do you want to say to those who remain?

- If you have no children or spouse, who

will receive your estate and insurance proceeds? How will it be managed? Will large sums of cash be dumped as a surprise? Is this prudent?

- If you have a spouse, what if both of you die accidentally at the same time?

- Will the families fight? Bicker? Sue?

- If you have children, who will be their guardians? Who will manage the assets and insurance proceeds? Will the cash fall into the hands of the children when they turn 18? Is this prudent?

- If you have children from a previous marriage, have you designated how each will be treated? Will it create conflicts with your current spouse? Will it create sibling rivalry with children from a second marriage?

- If you and your spouse have children from several marriages, who gets what? How are they to be treated? Will the children's blood mother have input into how the distribution and management is handled? Will your current spouse be responsible for *your* children after you're gone?

- If you have inheritance, will it be directed in your blood line or to all children and step-children?

- If you have co-owned properties or business interests with partners, will they want your spouse as their partner after

you're gone? Will you want their spouse as your partner after they're gone? Will your spouse want to be their partner when you're gone? Will your children be their partner if you and your spouse are both gone?

- Who manages the assets and insurance proceeds for minor children? Who files all the fiduciary documents? Who makes decisions about what child receives what? How much? When? What if the child is on drugs? A Rhodes Scholar? A missionary? A bum?

Life is not always simple; it doesn't always look like *Leave it to Beaver*. You may have parents or in-laws who depend on you now or will be dependent on you in the future. The costs of **long-term nursing care** may be an expense you want to guarantee.

There may be other family members whom you want to include in your planning.

Young families often have low incomes and have not yet purchased their first home. If you are just starting out—or have dependents who are—you may want to modify the income-replacement formula to include an **ideal family income** level that is higher than the current income. Also, you may want to add mortgage payments and a home down payment to your calculations.

CONCLUSION

Knowing how much life insurance you need is probably the most important part of buying the coverage. The process of figuring out what you need includes three steps:

- **Needs analysis.** This is the technical review of your—or your family's—expenses and liabilities. It should give you a dollar amount or range of dollar amounts that can serve as a starting point for pricing insurance policies.

- **Identifying beneficiaries.** An integral part of figuring out how much coverage you need is figuring out whom you want to benefit from your policy. This is an especially important part of the process if your family (the usual beneficiary of a life insurance policy) is large or complicated.

- **Examining policy terms.** Life insurance contracts aren't regulated as strictly as other kinds of insurance, so there can be substantial difference between policies. You should pay particular attention to the provisions and exclusions sections of any life insurance you consider buying. These are the parts of the contract that usually limit how, when and how much insurance will be paid when you die. These issues impact how your insurance needs are met so much that you should consider them from even this early stage.

It is important to understand the **language** of life insurance to fully understand the different types of protection provided against the risk of premature death. In Chapter 3, we will discuss some terms that are important to understand when purchasing life insurance.

CHAPTER 3

IMPORTANT
DEFINITIONS

INTRODUCTION

The life insurance market changes all the time—in tandem with the changing financial needs of people and groups. Annotating every variation of life insurance would take several long books. In this chapter, we'll take a look at the key definitions which control life insurance coverage.

These definitions will include all of the basic ideas and language that set the conditions of life insurance coverage. Even if you're considering more complicated variations—like annuities or variable universal policies—this chapter should give you a sound basis for asking useful questions.

AGE

References to an insured person's **age** may be found in premium and benefit provisions. For the purposes of determining life insurance premiums and values, any reference to an insured's age means the age as of the **nearest birthday**.

Example: Your 30th birthday is August 12 of this year. If your policy takes effect in January, the premium will be based on age 29. If your policy takes effect in September, the premium will be based on age 30.

ASSIGNMENT

A policy may include the following clause:

> This policy may be assigned by the Owner. We are not bound by any assignment until it is received at our Home Office. We are not responsible for the validity of an assignment.

The policy owner may assign some or all of the rights under the policy to another person. These include the right to choose or change the beneficiary, to change the method of premium payments, and to select settlement options for the payment of proceeds.

There are two types of assignments of life insurance contracts. The **absolute assignment** gives the assignee every right in the policy the owner possessed before the assignment—all **incidents of ownership** are transferred. Of course, the assignee can receive only the rights the owner had himself. Thus, any assignment is subject to debts owed to the insurance company. Upon the completion of an absolute assignment, the prior owner retains no ownership interest whatsoever.

A more limited type of assignment is the **collateral assignment**. The collateral assignment is used to provide security (collateral) for some transaction between the owner of the policy and the assignee.

> For example, the policyholder may borrow money and make a collateral assignment of the policy to serve as security for repayment.

If a collateral assignment is made, only some of the incidents of ownership are transferred to the **assignee**, generally for a limited period of time. The assignee receives only those rights necessary to provide security for the loan. Thus, the owner retains some ownership rights.

BAD FAITH

Some life insurance companies will go to great lengths to enforce the exclusions in their policies. In this process, they'll sometimes risk some damning **bad faith** claims.

The supreme court of Alabama's 1990 decision *Barbara Caroline Thomas v. Principal Financial Group* summed up the terms of bad faith in an insurance context:

> ...the plaintiff in a "bad faith refusal" case has the burden of proving:
>
> (a) an insurance contract between the parties and a breach thereof by the defendant;

(b) an intentional refusal to pay the insured's claim;

(c) the absence of any reasonably legitimate or arguable reason for that refusal (the absence of a debatable reason);

(d) the insurer's actual knowledge of the absence of any legitimate or arguable reason;

(e) if the intentional failure to determine the existence of a lawful basis is relied upon, the plaintiff must prove the insurer's intentional failure to determine whether there is a legitimate or arguable reason to refuse to pay the claim.

In short, the plaintiff must go beyond a mere showing of nonpayment and prove a bad faith nonpayment, a nonpayment **without any reasonable ground for dispute**.

BENEFICIARY

A policy may include the following clause:

> The beneficiary choice in the application will stay in effect unless changed by the Owner. If there is no beneficiary living or chosen, the proceeds will be paid to the Owner or his estate.

A **beneficiary** is the person or institution that receives the proceeds of an insurance policy when the insured person dies. The beneficiary can be the owner of the

policy, a third party or just about anyone —except the insured person.

A **beneficiary designation** stays in effect unless changed by the owner.

> Policy proceeds will be paid to the owner or the owner's estate if there is no living beneficiary at the time of an insured person's death.

CONTRACT

A policy may include the following clause:

> This insurance is granted in consideration of the application and payment of the scheduled premiums. This policy and the application attached at issue are the entire contract. All statements made in the application are deemed representations and not warranties. No statement shall void the policy or be used to defend a claim unless it is contained in the application.

The policy and attached application are the entire **contract**. Statements made in the application are now treated as **representations** rather than warranties. Under the law, a **warranty** carries more weight than a representation, and any breach of warranty (whether or not material) could void the insurance policy.

> To the extent that the insurance company may challenge the policy or deny a claim during the first two years of coverage, it may do so only if a misrepresentation is material and is contained in the application.

FREE LOOK

In most states, no life insurance policy can legally be issued unless it has printed on or attached to it a notice stating that, during a period of 10 days (some companies allow 20 days) from the date the policy is delivered to the policyholder, it may be **surrendered to the insurance company** together with a written request for cancellation of the policy. In such an event, the policy shall be void from the beginning and the insurer shall **refund any premium paid.**

This provision allows the policyholder an opportunity to review the entire contract and reevaluate the purchase decision.

GRACE PERIOD

A policy may include the following clause:

> If a premium is not paid on or before the due date, it is in default. There is a grace period of 31 days from the due date. During this period, the policy will remain in force. After that, if your premium is unpaid this policy will expire....

Technically, all premiums are due on the **due date**. The policy provides a **grace period** of 31 days for late payments. This does not extend the due date (the premium is still in default), but it keeps the policy in force until the end of the grace period.

If an insured person dies during the grace period while a premium is late, one month's premium will be subtracted from the proceeds.

If the premium remains unpaid at the end of a grace period, the policy will **expire** or **lapse**.

INCONTESTABILITY

A policy may include the following clause:

> This policy may not be challenged after it has been in force during your life for 2 years from the Date of Issue except for failure to pay premiums. This provision does not apply to added benefits for disability or accidental death.

The insurance company may only **challenge the validity** of a policy during the first two years that coverage is in effect. After that time, the policy may not be contested or coverage denied for any reason except nonpayment of premiums.

> Two years is a reasonable amount of time for the insurance company to discover any misstatements, errors or omissions made in the application.

INSURING CLAUSE

The **insuring clause** states that in consideration of the payment of premiums, the company agrees to pay the face amount to the named beneficiary, upon due proof of death of the insured, or to pay certain benefits if the insured lives to some specified age, such as 65. It sets forth the basic agreement between the company and the insured.

INTENTIONALITY

If the death of an insured person results from **intentional behavior**, an insurance company doesn't have to pay any accidental death benefit. The 1994 California Supreme Court decision *Lola Weil et al., v. Federal Kemper Life Assurance Co.* dealt with several important issues. Chief among these: the application of an **intentionality exclusion** and the difference between the concepts **accidental means** and **accidental death**.

In April 1975, Federal Kemper issued a life insurance policy which named Michael Weil as the insured. It was a term policy, renewable to age sixty-five. Its face amount was $100,000 and it provided a supplementary rider offering an accidental death benefit in the same amount—the traditional double indemnity clause.

Michael Weil died in August 1985, in a hotel room in San Francisco. He was 32 years old. A female prostitute said that she watched him ingest cocaine for nearly an hour from a dish in the bathroom. A short time later, he suffered shortness of breath and collapsed. Attempts by paramedics to revive him proved to be unsuccessful. A subsequent medical examination found that Michael had died of "acute cocaine poisoning."

Federal Kemper paid the $100,000 basic benefit provided in the policy to Lola and Michelle Weil—Michael's beneficiaries. The company denied their claim for the additional $100,000 accidental death benefit, on the grounds that Michael's death did not occur solely by accidental means within the meaning of the policy.

Lola and Michelle Weil sued Federal Kemper. They argued that, even if the cause had been acute cocaine poisoning from intentional ingestion of cocaine, Michael's death occurred by accidental means within the meaning of the policy—because he had not intended to kill himself.

The trial court sided with the Weils. It ordered Federal Kemper to pay the additional accident benefit of $100,000.

Federal Kemper appealed, arguing that the trial court had misinterpreted the phrase *accidental means*. While Michael Weil had suffered an accidental death, the insurance company argued, the death hadn't occurred because of accidental means.

The state supreme court noted that, in states that had

repudiated the distinction between *accidental means* and *accidental death*, insurance companies were frequently held liable for unintentional drug overdoses.

In the Weils' case, the court stuck to the language of the policy, which took pains to use the phrase *accidental means*. In order to collect the additional money, the Weils bore the burden of establishing that Michael's death was caused by an accident unrelated to his intentional ingestion of cocaine. Since they hadn't done that, the court reversed the award of the second $100,000.

MEDICAL EXAMINATIONS AND AUTOPSIES

Some states require life insurance policies to include a provision that gives the insurer the right and opportunity at its own expense to conduct a **medical examination** of the insured person as often as reasonably required when a claim is pending—and to make an **autopsy** in case of death where it is not forbidden by law.

MISSTATEMENT OF AGE OR SEX

A policy may include the following clause:

> If your age or sex has been misstated, any amount payable shall be such as the premium paid would have purchased at the correct age or sex.

> Example: Cindy, age 37, applies for whole life insurance. By mistake, her age is recorded as 35 on the application. The policy is issued and the premium is based on age 35 rates. Forty years later, Cindy dies and the misstated age is then discovered. Cindy has paid a premium which was lower than it should have been. The death benefit will be decreased slightly to reflect the amount of insurance which should have been purchased (with the premium that was paid) had her correct age been stated.

Due to gender differences in **life expectancy**, males usually pay more for life insurance than females (who live longer). Therefore if the insured person's sex has been misstated on the application, an **adjustment in the death benefit** will be made.

> If the mistake is found while the insured is alive, an adjustment in the premium will be made. The premium adjustment will usually include a new, higher premium and a request for additional premium to take care of the amount which should have been paid in the past.

MODIFICATION

A policy may include the following clause:

No person except the President, a Vice Presi-

dent, the Secretary or an Assistant Secretary can modify this contract on our behalf. No agent may bind the Company by making a promise not contained in this contract.

Modifications or changes in the policy, or any agreement in connection with the policy (such as changes in the beneficiaries, face amount, or additional coverage), must be endorsed on or attached to the policy in writing over the signature of a specified officer or officers of the company. No one else has any authority to make changes or agreements, to waive provisions, or to extend the time for premium payment.

> An agent or broker cannot obligate the company by making a promise which is not part of the contract.

Some modification clauses go further and specifically state that no agent has the right to waive policy provisions, make alterations or agreements, or extend the time for payments of premiums.

OWNER

The **owner** of a policy is the person who makes the contract with the insurance company. The owner has various rights and obligations (such as **designating a beneficiary** and **making premium payments**).

The owner does not have to be the person insured (when a parent takes out a policy covering a child, the child is the *insured* and the parent is the *owner*).

PARTIES

When a life insurance policy is issued, a number of **parties** may be involved with respect to **contractual obligations and benefits.**

Obviously, the insurance company is a party to the contract—in exchange for the premium payment, it has agreed to pay certain benefits if the insured dies. Since the insurance will pay a benefit if the insured dies, it is also obvious that the person insured is a party to the contract. But there may be other parties.

To identify other interested parties, you need to consider who owns the policy, whose life is insured, and who is entitled to the benefits. In the life insurance business, these parties may differ depending upon how the policy is issued and what rights are exercised.

PAYEE

The **payee** is the person entitled to benefit payments under the policy. Usually, this is a **designated beneficiary.**

PREMIUM PAYMENT

A policy may include the following clause:

Each premium is payable on or before the due date. The first premium is due on the Policy

Date. Upon request we will send a signed receipt....Premiums may be paid once per year, twice per year or once per quarter. The Owner may change the mode of payments if we approve.

Life insurance does not take effect until the first premium is paid, so the first premium is due on the **policy date**. Future premiums are due on or before each **due date**.

For a particular policy, premiums may be paid annually, twice a year, or once every three months. After the policy is in effect, the owner may change the mode of premium payment—if the insurance company approves (for example, annual payments may be changed to quarterly payments).

PROCEEDS

Proceeds are any moneys payable as a death benefit.

If a policy has an original face amount of $100,000 and dividends have been used to buy $5,000 of additional insurance, then the proceeds equal $105,000 at that point in time. On the other hand, if the policy owner has borrowed $50,000 against the policy, the proceeds would be only $55,000.

POLICY CHANGE PROVISION (CONVERSION OPTION)

The policy may contain a provision which permits the insured to **exchange a policy** for another type of policy form permitted by the company. This exchange is usually made from one policy type to another policy form with the same face amount.

If the exchange is to a policy with a higher premium, then the insured merely has to pay the higher premium and no proof of insurability would be required.

If the exchange is to a policy form with a lower premium, then **proof of insurability** may be required (this usually means another medical exam), as the exchange could result in **adverse selection** against the insurance company.

Example: If Charlie discovers that he only has six months to live, then he might decide to exchange his higher premium whole life policy for one-year term insurance with the same face amount. The insurance company's risk has increased while its premium income has decreased. Thus, Charlie will have to prove insurability.

POLICY DATE AND DUE DATE

The **policy date** is usually the original **effective date**. It is treated as an **anniversary date** and used to determine premium due dates and other dates.

The **due date** is simply the date on which all premium payments, after the first payment, become due.

Example: Your policy takes effect on May 8 of the current year, and that is the policy date. May 8 will be the anniversary date for the policy. If premiums are payable annually, they will be due on May 8th of each year. If premiums are payable monthly, they will be due on the 8th of each month.

REINSTATEMENT

If the premium has not been paid by the end of the grace period, this provision allows the policy owner to apply for **reinstatement** within a specified period of time **following the policy's lapse.** In most states, this period of time is at least three years. Some states or companies allow up to five years.

Usually the reinstatement process includes the submission of a reinstatement request or application by the policy owner, evidence of continued insurability and the payment of all back premiums plus interest. In addition, any outstanding loans or other indebtedness against the policy will have to be paid.

The insurer has the right to decline the request for reinstatement if, for example, the insured person is unable to provide satisfactory evidence of continued insurability. Any statements made on the reinstate-

ment application are subject to a new incontestable period (usually two years).

There are several reasons for considering reinstatement. These include:

- the lapsed policy may have more liberal policy provisions,

- the older policy may offer lower interest rates on policy loans,

- suicide and incontestable clauses probably will no longer apply if the policy is three years old or older, and

- the lapsed policy probably has a lower premium than a new policy.

This last point is especially true if you purchased the lapsed policy 10 or 15 years earlier. Instead of paying attained age rates for a new policy, you may be able to reinstate the lapsed policy at original issue age rates.

Normally, the reinstatement request will be approved. However, if the policy has not been in force for some time, you may find it better to purchase a new policy rather than pay back premiums plus interest to reinstate the lapsed policy.

RENEWAL

The policy schedule for annual **renewable term insurance** will show a policy date (original effective date) and an expiry date (expiration date), plus renewal premiums for the insured person's attained age up to age 69.

If the policy owner does not pay a **renewal premium**, the policy will expire. But it may be renewed for another year on any expiration date before the anniversary date nearest an insured's seventieth birthday, without a medical exam or evidence of good health, simply by paying the renewal premium.

> **Example:** If the policy has an anniversary date of June 1 and your birthday is August 1, it may not be renewed after your sixty-ninth birthday. On the next policy date, your nearest birthday will be your seventieth, which will be treated as your attained age for policy purposes (although coverage actually ends at age 69 and 10 months).

SUICIDE

A policy may include the following clause:

> If you die by suicide, within 2 years from the Date of Issue your insurance shall be limited to the amount of premiums paid. This applies whether you are sane or insane at the time of suicide.

Nearly all life insurance policies have a **suicide limitation**. If an insured person commits suicide within the first two years after the effective date, the insurance company is only obligated to return the premiums paid. After two years, it is assumed that a person did not buy insurance with the intent of committing suicide and death by suicide is covered.

UNIFORM SIMULTANEOUS DEATH ACT

A problem arises when the insured person and the primary beneficiary **die simultaneously**. Many states have adopted the **Uniform Simultaneous Death Act**. Under this law, if there is no evidence as to who died first, the policy will be settled as though the insured survived the beneficiary.

Accordingly, the life insurance proceeds would be paid to the estate of the insured, not the estate of the beneficiary.

Of course, if contingent beneficiaries are designated, the proceeds would be payable to them. Or if there is clear evidence that the beneficiary survived the insured, then the proceeds are payable to the beneficiary's estate.

To avoid the problem of the primary beneficiary living for a very short time following the death of the insured and thus receiving the insurance proceeds, many policies will include a **common disaster** provision. This provision places a **time element** on the sur-

vival period of the primary beneficiary by stipulating that the primary beneficiary must survive the insured by a specified period of time such as 30, 60 or 90 days.

CONCLUSION

This chapter considered only a few of the important definitions involved in purchasing life insurance. Throughout the book, there will be more definitions which impact life insurance coverage and purchasing a policy.

CHAPTER 4

THE MECHANICS OF TERM INSURANCE

INTRODUCTION

Term life insurance is **temporary insurance** that essentially provides a death benefit only. The benefit is paid only if the insured person dies before the end of the specified term (whether it be one year, five years, ten years or some other term). If the insured lives beyond the end of the term coverage, the policy simply expires.

> A term policy does not build any cash, loan, or surrender values.

Since term insurance does not build **cash value**, a policy owner only has to pay for the death benefit and policy expenses. For this reason, it is usually the **least expensive form of life insurance**. It may be used as an inexpensive tool to satisfy a variety of temporary insurance needs, such as a mortgage obligation or the need to protect insurability until an insured can afford permanent protection.

> Premiums start low and increase over time. They do not accumulate cash. In later years, they are generally too expensive to maintain.

Term insurance makes sense if you:

- are strapped for cash,
- do not need insurance for more than fifteen years,
- are young,
- think like a renter rather than a buyer, or
- are in a low income tax bracket.

There are different types of term policies. **Level term** provides a consistent amount of insurance. **Decreasing term**, which is an ideal type of insurance to cover any shrinking debt obligation (like a mortgage), starts with a specified face amount which decreases annually until it reaches zero at policy expiration. **Increasing term** provides a growing amount of insurance over the course of the term. This type of policy is rare.

Other common types of term life insurance include:

- Annual Renewable Term
- Yearly Renewable Term
- 5 Year Level Term
- 10 Year Level Term
- 15 Year Level Term

- 20 Year Level Term

- Mail Order Term

- Association Group Term

- Employer Group Term

The most common of these is the **15 Year Level Term** policy. If you are considering a term policy and haven't heard differently, it's probably 15 Year Level Term insurance.

Level premium term solved three problems for insurance companies:

- **Demographics**. With baby-boomers entering their thirties in the 1980s, there was a huge increase in demand for life insurance. The size of the policies purchased grew. The typical policy of $100,000 or $250,000 in the 1960s and 1970s gave way to policies of $500,000 and $1,000,000 in the 1980s.

- **Cash strapped young families**. With inflation increasing housing costs during the 1980s, the size of mortgages outpaced income growth. So, the need for family security and income continuation increased while income for most families remained fairly steady.

- **Falling prices**. Term insurance rates started falling in early 1980...and have continued falling through the 1990s. Any term policy purchased five years ago could be replaced with a new cheaper

one. And many were. This move to cheaper premiums had a chilling effect on the entire insurance market.

As a result of these market factors, a handful of cheap term carriers came to dominate the marketplace. They fell over each other—slashing prices and increasing commissions—to increase sales. Level term helped the market stabilize in the wake of these price-cutters.

Among the things you should do when selecting level term insurance:

- Select a company with high financial ratings (even if it is slightly more expensive).

- Compare level period costs.

- Compare premiums after the level period (both if you qualify and if you don't).

- Find out whether the premiums after the level period are guaranteed or illustrated.

- Ask whether you can convert to all products offered by the company during the level period.

- Ask whether the standards for medical requalification at the end of the level period will be the same for all applicants—and whether this is clearly written in the contract.

- Avoid tricky contract clauses by buying from top quality carriers and avoiding mail order plans and association group plans.

RENEWAL AND CONVERSION

Many term policies are **renewable**, which means they may be renewed without providing evidence of good health until a specified age. A one year renewable term policy expires after one year but is renewable for other one year periods. A five year renewable term policy can be renewed for subsequent five year periods.

> A caveat: Because of an insured person's advancing mortality (that is, increasing chance of death as he or she gets older), renewal premiums will always be higher than previous premiums.

Many term policies are also **convertible**, which means they may be exchanged for another type of policy—such as whole life. If the conversion privilege is exercised it will be at the **attained age**—meaning the premium paid for the new policy will be the insured's age at the time of conversion.

Assuming the level term policy is issued as renewable and convertible, every time the policy renews for a subsequent term period, the policy's premium will increase due to the increased age of the insured.

> Example: You have purchased $50,000 of one-year renewable and convertible term insurance. Each year the policy is simply renewed at the same face amount by the payment of the new, higher premium. A new application is not required nor is a new policy issued. The only thing which changes is your age—and, subsequently, the policy's premium.

Decreasing term is also temporary protection for a specified period of time. However, the death benefit decreases but the premium remains level or constant for the term of the policy.

> Decreasing term is usually written as convertible but generally is not renewable at the end of the specified term period.

PROVISIONS

In the ordinary term policy, the insurance company agrees to provide insurance on the insured's life and to pay the benefits listed. The benefit, or "face amount" of insurance shown in the **policy schedule**, will be paid to the beneficiary upon proof that the insured died while the policy is in force.

An **annual renewable term** policy may be renewed annually, or converted to another type of policy at any time, until the insured reaches age 70.

The **policy schedule** for annual renewable term insurance will show a policy date (original effective date) and an expiry date (expiration date), plus renewal premiums for the insured's attained age up to age 69.

An example: If your birthday is March 1 and the policy anniversary date is June 1, it may be renewed after your sixty-ninth birthday. On the next policy date, your nearest birthday will be the sixty-ninth (although coverage in this case will actually continue for three months beyond age 70).

Many term policies will include language that instructs you to contact the company's **home office** about any change that might affect terms or conditions. This **provision** encourages the policy owner to contact the insurance company for assistance when changing an address, collecting benefits, or considering exchanging policies.

You should read the entire policy carefully. An insurance policy is a legal contract, and the policy provisions specify both the rights and duties of the policy owner and the insurance company.

PARTICIPATING TERM POLICIES

Some term policies are **participating policies**. While in force, they will share in any **divisible surplus** of the company's participating business as determined each year by the company.

Participating insurance usually costs a little more than non-participating insurance. Dividends, if any, are due on policy anniversaries. The dividend at the end of the first policy year will be payable only if the premium then due for the second policy year is paid.

The owner of a participating policy has options as to **how dividends will be received.** They may be taken in **cash** or applied toward **premium payments.**

If you wish, dividends can be held by the insurance company to earn interest—and you can receive them later. They may also be used to buy one year term insurance additions—as much coverage as the dividend will purchase at the insured person's attained age (this option is often selected when a policy owner needs more insurance than he or she can afford).

TERM ADDITIONS

Additional amounts of term insurance are available only if the policy is in a **standard premium class** and it is requested in the application or by a later written request. When a policy is issued as **nonstandard,** it means the insured person poses a higher risk. An insurance company is not usually willing to provide additional amounts of coverage under this option.

When **term additions** have been purchased, the additional benefit is payable when the insurance company receives proof that death occurred within one year after the dividend was paid.

> Term additions usually expire on the next anniversary date, so they may not accumulate from year to year.

The premium charge for term additions is based on the extended term mortality table being used by the insurance company for the policy in effect.

An insurance company will usually provide life insurance coverage in **increments of $1,000**. If term additions are elected, any part of a dividend not used to buy additional insurance may be taken in cash, applied toward a premium, or left with the company. If no other option has been elected, the insurance company will automatically apply dividends toward premium payments for existing coverage (it will reduce the net amount due).

> Dividends left with the company to earn interest may be withdrawn by the policyholder at any time. Any dividends not withdrawn or used will be paid to the owner upon the death of the insured or expiration of the policy.

EXCHANGES AND CONVERSIONS

A term life policy may be **exchanged** for a whole life policy or endowment policy at any time before the insured reaches an attained age of 70. Evidence of good health is not required. Written application must be made for the desired exchange option.

Under an **original age option**, a new policy will have the same effective date as the term policy and the premium will be based on the insured's age as of that date. Since the **values** of the policy (cash value and net death benefit) are based on premium payments, cash accumulations, and interest earned since the effective date, the policy owner must pay the accumulated difference between the premiums for the two policies plus interest.

The interest rate is predetermined (often between six and eight percent annually). Adjustments will also be made for differences in dividends.

Example: You purchased the term policy at age 30 and decide to convert it to a whole life policy at age 45 under the original age option. The accumulated difference between the premiums for the two policies is $4,826. Compound interest on the unpaid amounts equals $1,238. The difference between dividends paid and those that would have been paid under the whole life policy is $912 (since whole life would have paid higher dividends, this amount is subtracted). You must pay $5,152 ($4,826 + $1,238 − $912) to have a current whole life policy with all values up to date as if it had been purchased at the original age.

Under an **attained age option,** a new policy will have a current effective date and the premium will be based on the insured's attained age when it is issued. The policy owner only needs to pay the current premium, which will be higher than it would have been at the original age.

In this scenario, the new policy will not initially have any accumulated cash value. This will begin to accumulate only in future years.

Example: You purchased the term policy at age 30 and decide to convert it to a whole life policy at age 45 under the attained age option. By doing so, there is no need to pay any differences in past amounts, but the premiums for a policy starting at age 45 may be considerably higher than they would have been at age 30.

If you had elected to use **dividends** to purchase one year term additions, any available option may be exercised under the new policy without evidence of good health at any time before the third anniversary of the new policy. After that date, **limitations** may apply. The most common of these: **Evidence of good health** may be required before the insurance company will approve the exchange.

If the term policy includes **additional benefits**, such as disability or accidental death benefits, similar benefits may be included in the new policy if the insurance company regularly issues those benefits under the plan, rated age, and risk classification of the insured on the effective date.

Disability benefits may be included in the new policy without evidence of good health at any time before the third anniversary of the new policy only if the premium payments for such benefits are level to age 90. After that date, evidence of good health will be required before disability benefits may be included in any policy.

CONVERSION LIMITATIONS

Your right to convert a term policy to a cash value policy without medical examination is very valuable. When an insurance company restricts this **conversion right**, you risk not being able to convert the policy in the future.

The bold print on a convertible term policy may read *Guaranteed Convertible*—but fine print may say *for five years only* or *to age 70*. Some policies will have limited conversion timeframes—such as the first three years that you own the policy. Others limit the types of policies to which you can convert.

If a company restricts the right to convert, it is getting off the hook at the very time the chances of death become more likely. Look for convertible policies and look carefully for restrictions or limitations.

The following chart compares the common conversion conditions that apply to term policies.

$500,000 Death Benefit
Male, Age 45

| | | No Re-Entry Required | | | Re-Entry Required | |
| | | | | | If You *Pass* Re-Entry Medical | If You *Fail* Re-Entry Medical |
Age	Year	Yearly Renewable Term	10 Year Level	20 Year Level	10 Year Level	10 Year Level
45	1	$680	$820	$1,100	$790	$790
50	5	$900	$820	$1,100 (2)	$790	$790
55	10	$1,300	$820 (1)	$1,100	$790 (5)(7)	$790 (7)
60	15	$2,250	$1,500	$1,100	$1,785	$6,200
65	20	$4,500	$1,500 (3)	$1,100 (3)	$1,785	$10,185
70	25	$8,500 (4)			$16,755 (6)	$16,755

(1) End of ten year period, premiums increase to new level — no medical required
(2) Convertibility restricted to five years
(3) Coverage ends at twentieth year
(4) Convertible to age 70
(5) End of tenth year, premium increases to $1,785 IF the medical is passed
(6) At age 65, the premium increases rapidly, even if medical is passed
(7) Must convert within ten years

BUYING STRATEGIES

> Don't be seduced by cheap premiums into giv-
> ing up control of options. Select your policy
> as if this is the last policy you will be able to
> purchase. This will help you to avoid poor qual-
> ity companies, gimmicks, loss leader pricing
> and requiring medical requalification.

Most people buy term insurance for one of two rea-
sons:

- They only need coverage for a limited
 period of time and do not plan to convert
 to cash value insurance in the future, or

- They can afford cash value insurance
 now but may convert to cash value in-
 surance in the future.

> If you never plan to convert, the price will be
> the primary consideration.

Price becomes less important and other factors play a
more significant role if you want to keep the insur-
ance longer or convert it. In these cases, you should
consider:

- the quality of the issuing insurance com-
 pany,

- conversion restrictions (time limits), and

- requirements for medical exam upon re-
 newal in the future.

**You shouldn't assume that your health will be
as good as it is now in the future.**

A popular development in recent years has been term
insurance with a **level premium** for the first 5 years,
10 years, 15 years or 20 years. After the level period,
you are required to take a medical examination to
avoid a dramatic **premium increase**.

If your health is not perfect, your premium increases
dramatically. These policies appeal to some of the
worst impulses in buyers:

- consumers want cheap prices today and
 hope for good health in the future—
 therefore, millions have purchased poli-
 cies which they may have to cancel when
 they most need to keep it; and

- insurance companies get to keep the con-
 sumers' money and dump the risk when
 a consumer discovers he or she has health
 problems.

Example: At age 59, a successful businessman finds out that his wife is pregnant with twins. Within a week of this news, he finds out that he has a serious heart problem—which makes him insurable only at a very high premium. His existing insurance was the cheapest term insurance available when he'd bought it—eight years before. This coverage required that he pass a medical in the tenth year. If he didn't pass the medical examination, the premiums would triple in price...and continue up from there.

He realized that, since his children would be born when he was 60, they would be entering college when he was in his late 70s. By that time, premiums for $1,000,000 of term coverage would be almost $100,000 a year.

This otherwise smart man had purchased the cheapest policy at age 51 thinking he wouldn't need it in the future. He guessed wrong. If he had purchased a policy that didn't have a medical re-entry and was a high quality company, he would have had affordable options.

CONCLUSION

Only a small percentage of people die owning term policies. Why is this? Most people die between the ages of 65 and 85 years old. The premiums for term insurance become so expensive by 60 years old, that people **cancel** the term policy or **convert** it to another form of life insurance.

> Term life insurance is a form of temporary coverage which may suit you and your family if you foresee a change in your insurance needs over time. And even though term policies provide temporary coverage, they may be renewable or convertible, or both.

How much should a term life insurance policy cost? That's like asking: How much does a house cost? Or a dress? Or a car?

Let's use the analogy of a house: If the price is low, there may be problems with the house or the neighborhood. If a term policy is cheap, there will be contract restrictions in the policy or it may be written by a low-quality company.

> Insurance companies will always give you a discount if you take more risk.

Are you willing to bet that 5, 10, 15, or 20 years from now you will be perfectly healthy? No problems with heart, cancer, blood pressure, diabetes, liver functions, psychological problems, etc. That is the bet you make when you purchase level term. Only you can decide whether the risk is worth the savings.

If you only need insurance for the level term period (5, 10, 15, or 20 years), level term is **less expensive** than annual renewable term. If you need coverage after that time, that insurance may not be the best kind for you. Also, if your health falters and you don't pass the medical at the end of the level period, level term is **more expensive** than annual renewable term.

> A medical exam is usually required at the end of the level period. Negative medical changes (heart, blood pressure, cholesterol, cancer, respiratory, nervous conditions, etc.) will substantially increase your premium.

On a 10-year level term policy, the cumulative 10 year premium is almost always lower than 10 year cumulative premium of yearly renewable term.

Term insurance may or may not be right for your insurance needs. It can provide a maximum amount of insurance for a very low cost—but, again, it is only temporary protection. It is important to understand the provisions before choosing a term policy because

the adequate insurance that was once provided can cause potential disadvantages at the end of the insured term. These disadvantages include **loss of insurability, higher premium costs at renewal** and **absence of cash value.**

In the next chapter, we will discuss whole life insurance which provides a guaranteed form of protection which—unlike term—provides cash value and coverage for your whole life.

THE MECHANICS OF WHOLE LIFE INSURANCE

INTRODUCTION

Unlike term life insurance—which has no value after a set period of time—there are some forms of life insurance that build a **cash equity value** over time. These are the most common kinds of so-called *cash value* insurance:

- whole life,
- universal life,
- blended whole/universal life,
- interest sensitive whole life,
- variable life,
- variable universal life, and
- variable blended whole/universal life.

In most of these cases, premiums start higher than term insurance—but they stay level...and the policy accumulates a redeemable cash value as time goes on. This kind of insurance makes sense if you:

- are accumulating cash for the future,

- need coverage for more than 15 years,

- think like a homeowner,

- are in a high tax bracket,

- are over 35 when you buy your first policy.

The most common of these kinds of insurance is **whole life**. Whole life insurance is a permanent form of insurance protection that combines a death benefit with cash value accumulations.

In a whole life policy, the face amount is constant—and this amount will be paid if the insured person dies at any time while the policy is in effect. Premium payments are fixed and remain the same from the original effective date to the maturity date.

The policy is designed to **mature** at age 100—the age when premium payments would end and the cash value would equal the face amount. At maturity, the face amount is paid to the beneficiary if the insured person is still living.

That's a good incentive—even better than being mentioned by Willard Scott on the *Today* show—to make it to 100.

Although whole life policies are one of the most common forms of life insurance sold, most people do not plan on paying premiums until age 100. More commonly, whole life insurance is used as a form of **level protection** during the income producing years. At retirement, many people then begin to use the accumulated cash value to supplement retirement income.

> Whole life plays an important role in financial planning for many families. In addition to the death benefit or eventual return of cash value, the policy has some other significant features. During a financial emergency, policy loans may be taken and the full policy values may later be restored. If the contract is a participating policy, it may also pay dividends.

Most of the **preliminary language**—setting provisions, terms and conditions—is the same for whole life and term life policies.

POLICY LOANS

The issue at which whole life policies diverge from term is the fact that you can **borrow against equity** value you build in a whole life policy. The insurance company will make loans against the **net surrender value** of the policy.

Usually, borrowing is a straightforward process. Your agent or the life insurance company's home office will send you a loan form on your request. On this form, you will be asked for the amount of the loan, your tax ID number, your address and policy number. Within a matter of weeks—or sometimes days—the insurance company will send you a check.

The policy is used as **security** for the loan. The insurance company will not lend an amount which, with interest, would exceed the net surrender value of the policy. However, **overdue repayments** plus interest can push a policy into default.

A whole life policy will include a table of values that shows cash or surrender values at the end of various policy years. Usually a policy does not have a cash value until the **end of the third policy year**, because nearly all of the premium in the first few years is used to cover mortality costs, expenses of issuing the policy, and commissions.

When the owner of a policy borrows money, interest is charged just like any other loan. Therefore, if the borrowing continues, the interest amount will increase each year.

Most companies want to see the loans repaid as quickly as possible, so they make it as easy as possible to accomplish. The loan may be paid in a lump sum, periodic payments, interest-only payments, or applying any dividends generated by the policy. Details on borrowing and repayment can be obtained from an agent or directly from the insurance company.

It is possible to take money out of the policy in the form of loans—and continue to keep the death benefit in force.

A policy loan **reduces the value** of a policy. Any amount outstanding will be deducted from the proceeds if the insured dies or surrenders the policy for its remaining cash value.

Most policies provide for **automatic premium loans** against cash value to prevent a lapse in coverage when a premium is not paid before the end of the grace period. In order for this to take effect, the policy owner must make a written request before the end of the grace period.

Once this arrangement is in effect, future **unpaid premiums** will be borrowed against the policy until the cash value is insufficient to cover a premium payment. As long as the policy remains in force, a policy owner may resume making premium payments without having to provide **evidence of insurability**. The automatic premium loan feature may be canceled at any time by written request.

Example: Sara's job was eliminated due to restructuring, and she finds herself on a tight budget. To minimize expenses, she requests that automatic premium loans be made to cover her quarterly life insurance payments. Two premium payments were paid in this manner. After six months, Sara found another full-time job and was then able to pay her next premium.

In order to **restore a policy** to its full value, an outstanding policy loan must be repaid with interest. The interest rate charged on a policy usually ranges between six and ten percent annually (though this number fluctuates with interest rates in general).

Unpaid interest is added to the amount of the outstanding loan.

Some people don't understand why they have to pay interest on their *own money*—the cash value they have borrowed. The reason is that the insurance company no longer has use of this money—it is no longer earning interest for the company.

Projected policy values (the face amount, cash value on future dates, etc.) are based on the assumption that premiums will be paid to cover mortality costs and expenses—and that there will be enough left over to invest and earn interest and equal the cash value. When the company does not have use of the money, these values fall short. So a policy loan must be repaid with interest to restore the contract to its full value.

PARTICIPATING POLICIES

Like term insurance, a whole life policy can be either **participating** or **non-participating**. A participating policy is usually preferable, because it can pay dividends.

Participating insurance costs a little more than non-participating insurance, but the insurance company may share its divisible surplus (profits) with participating policyholders. Dividends are not guaranteed. They are paid on each policy anniversary only when declared by the company.

The policy owner has options as to **how dividends will be received.** They can be taken in cash or applied toward premium payments. They can also be held by the insurance company and earn interest—then transferred later. Finally, they may also be used to buy ad-

ditional **amounts** of whole life insurance or one year term insurance additions.

When **whole life additions** are purchased with dividends, they usually comply with the terms, provisions and valuation schedules that apply to the underlying policy.

When **term additions** are purchased, the additional amount is payable when the insurance company receives proof that death occurred within one year after the dividend was paid. The premium charge for term additions is based on the extended term mortality table being used by the insurance company for the policy in effect.

LAPSE OR SURRENDER

After a whole life policy has a cash value, certain values are guaranteed upon the **lapse or surrender** of the policy. Any of these options (which are known as **nonforfeiture options**) may be elected in writing by the owner within 90 days of the due date when a premium is in default. If no election is made, one of the automatic options will apply—non-participating extended term insurance for a **standard premium class policy**, or participating paid-up insurance for a **special premium class policy.**

The **net surrender value** is the cash value, plus the present value of dividend accumulations and additions, minus any outstanding policy loans. Values are determined as of the **last premium due date.** Any **outstanding loans** that are subtracted from the surrender value will include any interest or other amounts charged against the policy after the due date.

> When the policy is turned in for its surrender value, the cash value will be paid (minus any loans and interest). The insurance company may delay payment for up to six months, in which case it will pay 3 percent annual interest on the amount held more than 30 days.

SURRENDER CHARGES

The **surrender charge** is a penalty the company charges the policy owner for terminating the policy during the first few years. It reduces the cash value of a policy to its surrender value.

> Example: Andy paid two years premium in advance on his universal life policy. Six months later, he lost his job and wanted to get some of his cash back. The company's surrender charges were more than 200 percent of his premium. The result was, after Andy had paid a two year premium and only had the policy for six months, the company refused to return any premium or cash value.

Comparing a company's **past projections to actual performance** is easy. In the following chart, we compare the actual and illustrated performance of two large United States insurance companies for a $1 million policy on a 45-year-old male purchased in 1974.

	Company A	Company B
Projections in 1970		
Premiums Paid	633,600	634,800
Projected Cash Value		
Guaranteed	463,870	439,000
Dividends	221,010	187,260
Projected 1990 Cash Value	684,880	626,260
Projected Surrender Index	9.06	10.55
Projected Net Payment	22.42	23.83
Actual Performance 1974-1994		
Actual Premium	633,600	634,800
Actual Cash Value		
Guaranteed	478,310	439,000
Dividends	431,122	323,290
Actual 1990 Cash Value	909,432	762,290
Actual Surrender Index	0.64	5.36
Actual Net Payment	14.41	18.63

SURRENDERING TO PURCHASE MORE INSURANCE

When used to purchase **paid-up participating insurance**, the surrender value will be used as a **single premium** to purchase as much paid-up whole life insurance as possible at the insured's attained age. The amount may not exceed the **death benefit** under the current policy plus additions and dividend accumulations (normally, it would be considerably less).

Since this additional insurance is **paid-up**, no further premiums will be due.

When used to purchase **non-participating extended**

term insurance, the surrender value will be used as a single premium to purchase the same amount of protection **for as long as possible** at the insured's attained age. The amount may include the amount of any paid-up additions and dividend accumulations.

Since this additional insurance is also paid-up, no further premiums will be due.

Example: Upon surrender of a $100,000 whole life insurance policy, Sam selects the extended term insurance option. The policy being surrendered has been placed for 7 years and 102 days. It includes $6,000 of additional paid-up insurance and $4,000 of dividends being held by the insurance company. The surrender value purchases a $110,000 fully paid-up term life insurance, which will remain in effect for 12 years and 263 days (the balance of a 20 year term).

While it remains in force, participating paid-up insurance or extended term insurance may also be surrendered for its **present value**. This value includes any cash value, the refund of unused premium due to early termination of the paid-up contract, plus any dividend additions or accumulations.

BASIS OF VALUES

The following passage—common in many whole life policies—explains **how values are determined** under the policy:

All net single premiums and present value referred to in this policy are based on the Commissioners 1958 Standard Ordinary Mortality Table, except that net single premiums for extended term insurance are based on the Commissioners 1958 Extended Term Insurance Table. The calculations are based on continuous functions, age nearest birthday and with an interest rate of 3 percent per year.

On any policy anniversary the tabular cash value of this policy shall equal the excess, if any, of (a) the then present value of the future basic benefits as defined in the policy schedule, over (b) the then present value of a series of annual amounts beginning on such anniversary and continuing during the remaining premium paying period. Each such annual amount shall equal the Non-Forfeiture Factor shown in the table of Guaranteed Values for the appropriate policy year.

Any supplemental agreement attached to this policy will not increase the cash values or paid-up insurance benefits unless otherwise provided in the agreement.

The Table of Guaranteed Values gives the values for the full face amount of this policy, provided this policy is free of indebtedness and has neither dividend additions nor accumulations. Allowance shall be made for lapse of time and payment of premiums beyond the beginning of each policy year. Any values not shown will be quoted on request. The entire loan value at the end of any policy year, less

interest for the intervening period, will be available during the same year if the entire premium for that year has been paid.

In this case, **net premium values** and **present values** are based on the mortality tables used for the kind of policy in question. Calculations include use of a person's age as of the nearest birthday and an interest rate of 3 percent annually.

The dollar amounts related to cash values are shown in the **table of guaranteed values** attached to the policy, and all values must be at least as great as the minimum amounts required by state law.

The table shows values for the full face amount of the policy. If there is any **outstanding policy loan**, it will reduce the value. If there are **dividend accumulations**, it will increase the value. Any values not shown will be quoted by the insurance company on request.

> Comparing surrender cost index history is perhaps the simplest most accurate form of policy comparison.

Consider the four companies and policies that appear in the chart below. The premiums (Row 1) for twenty years are almost the same. The cash values projected in 1975 were similar—but, in 1995, looking back at actual performance tells a different story.

	Company "A"	Company "B"	Company "C"	Company "D"
20 Year Premium	$44,100	$42,880	$43,840	$36,320
Projected Cash Value	$37,182	$37,493	$36,700	$30,939
Surrender Cost Index	3.96	4.60	6.03	4.88
A Lower Index is More Favorable Actual Cash Value	$37,182	$37,493	$36,700	$30,939
Surrender Cost Index	-1.25	-0.24	3.19	-1.30

CONCLUSION

Whole life insurance coverage provides **protection and savings** that remain in effect for the whole of your life. This type of life insurance is preferred by many and used widely for **security** because it combines protection and savings—two major factors in the financial plans of most families.

When you're considering a whole life policy, there are several questions you should ask your agent or insurance company. These include:

- What are the company's third party ratings by **Weiss Research, A.M. Best Company, Standard and Poor's** and **Moody's** rating services?

- How does your company's rating compare to the highest rating?

- What percentage of your **invested assets** are in **high risk assets** (for invested assets, exclude separate accounts and non-income or non-appreciating assets; for high risk assets, include bonds of below average or non-investment grade quality, bonds in or near default, mortgages in foreclosure or with payments overdue more than 90 days and real-estate acquired by foreclosure)?

- What is the company's Moody's Risk Adjusted Capital Ratio?

You should also ask the insurance company to provide the following:

	Most Current Year End	Prior 5-Year Average
Ratio of Capital and Surplus (Plus AVR) to Liabilities (Less AVR) and Separate Accounts	_____ _____ _____	_____ _____ _____
Lapse Ratio	_____	_____
Renewal Expense Ratio	_____	_____
Mortality Margin	_____	_____
Total Investment Return (Excluding Policy Loans, Including Capital Gains)	_____ _____ _____	_____ _____ _____

If you ask these questions, you will get one of three responses:

- "I don't have access to this information (because the company doesn't provide it or because the agent doesn't understand it)."

- "That's not important (because the in-
 surance company is so good, so old, so
 highly rated....)"

- "Would you like the summary version or
 the detailed version of this information?"

If the answer is either of the first two, you should prob-
ably stay away from the company and its insurance.

In the next chapter we will focus on a variety of **flex-
ible insurance** policies. Different types of policies may
allow the policy owner to vary the amount or timing
of premium payments. These policies provide con-
sumers with more options and attractive alternatives
to benefits, premiums, policy terms, and interest rates
than the traditional policies.

UNIVERSAL LIFE, VARIABLE LIFE AND GROUP POLICIES

UNIVERSAL LIFE

Universal life was the insurance industry's answer to the extremely high interest rates that Americans experienced in the 1970s. Traditional **whole life** contracts have earned 3½ to 5 percent interest. In an effort to be more competitive, many insurers developed universal life products with relatively high interest rates—8 to 12 percent. These higher interest rates provide universal life with its distinctive characteristic—**flexibility**.

> Universal life is basically a whole life policy divided into its two components—death protection and cash value. In essence, the death protection takes the form of one-year renewable term insurance and the cash value account realizes current interest rates.

The universal life policy was designed for people who need flexible coverage over the course of their lifetime. Flexibility is realized by the following factors:

- the policy owner may **increase or decrease the death benefit** subject to any insurability requirements,

- **premium amounts** may be changed as long as enough premium is paid to maintain the policy, and

- most universal life policies are sold based on the **accumulation values** and tax-deferred retirement income, rather than on the proposed death benefit.

Policy owners often misunderstand that returns can and do fluctuate, based on **investment performance** and **interest rates**.

Example: Your universal life premium is $1,000 annually for $100,000 of coverage. When the premium is paid, an amount necessary to provide one-year renewable term coverage is used to cover the death protection element of the policy. The balance is deposited into the cash account where it will earn competitive current interest rates.

PROGRESSIVE UNDERWRITING

Universal life competes in the **term insurance marketplace**. It can offer standard rates substantially

cheaper—as much as 30 percent or more—than standard rates charged by many term insurance companies.

Some universal life policies feature **progressive underwriting**, which is meant to attract otherwise uninsurable consumers. These policies are usually structured so that, if policy owners pay the **level minimum annual premiums**, coverage won't lapse for 15 or 20 years.

Some abnormalities can be caused by lifestyle rather than medical problems. For instance, a person might take a cough medicine to treat a cold, and this might cause an abnormality to show up on tests.

There are actually two interest rates associated with the universal life policy—the **current year guaranteed rate** and the **contract rate.**

The current guaranteed rate refers to the annual rate which is reflective of **current market conditions.** Thus, the current rate can change every year. The contract rate is the **minimum guaranteed interest rate** which the policy guarantees will be paid. For example, the policy's guaranteed rate may be 5 percent. This amount would be credited to the cash account if the current year's rate fell below 5 percent.

There are two options regarding the death benefit payable under a universal life policy.

The first option provides a **level death benefit** equal to the policy's **face amount**. As the policy's cash value increases, the mortality risk decreases. Thus, the cost of the **death protection** actually decreases over the life of the policy and—accordingly—more of the premium can be placed in the cash account. This is exactly the same concept which applies to whole life.

However, due to the higher current interest rates credited to the account, if the **cash value** increases to an amount equal to or in excess of the policy's face amount, then the death benefit will automatically be increased. Under current tax laws, if the universal life policy is to maintain its status as life insurance and thus provide a tax free death benefit, there must be a degree of mortality risk until the insured person reaches age 95. This is the reason for the **automatic increase** in the death benefit if the cash value equals or exceeds the policy's face amount. This buffer or corridor between the death benefit and the cash value must be maintained.

The second option provides for an **increasing death benefit** equal to the policy's face amount plus the cash account. Unlike the first option, the **mortality risk** remains at a level amount equal to the policy's face value. Thus, the policy owner will incur a **higher expense** for the cost of the death protection over the life of the policy and less of the premium will be deposited in the cash account.

Universal life provides for cash value loans in the same manner that whole life or any cash-value insurance policy does. If a loan is taken, it is subject to interest and—if unpaid—both the interest and the loan amount will reduce the face amount of the policy.

Many universal life policies will also permit a **partial surrender** or withdrawal from the cash account. This is not treated as a loan.

A partial surrender is not subject to any interest and will reduce the total cash value in the account. If this withdrawal is later repaid, it will be treated as a premium subject to any sales load that the policy may have.

VARIABLE LIFE

Variable life insurance provides death benefits and cash values that vary according to the **investment returns** of stock and bond funds managed by the life insurance company.

Historically, to offset imbalances in interest paid under a standard universal life policy, some insurance companies made special provisions for people to purchase life insurance and still take part in any increase in **interest earnings**. Today, most variable and flexible premium policies contain provisions that guar-

antee you certain interest earnings, which will not ever be less than a predetermined percentage (4 percent is a commonly used figure).

A typical policy provision may also state that interest will be the greater of the current interest rate or 6 percent per year.

Then, by actuarially calculated methods, the insurance company will also guarantee that you will make a certain percentage of the current interest rate should that interest rate go above the 3 percent or 4 percent interest that you need to earn. This additional interest percentage is the **excess interest** over the minimum guaranteed interest.

> **Example:** If the insurance company is earning 7 percent on an investment, you will earn the guaranteed 4 percent. But if the insurance company earns 11 percent, you may earn an additional 3 percent on the current interest rate. Therefore, the combined interest earnings will be 7 percent.

Essentially, variable life insurance is a whole life policy designed to protect the policy owner and the beneficiaries from the erosion of their life insurance dollars due to **inflation**.

An insurance company's **general investment account** usually consists of safe, **conservative investments** such as high grade bonds, real estate, certificates of deposit,

etc. The premiums from a **traditional life insurance contract** are placed in the general account and the entire contract is fully guaranteed by the company. But these conservative investments may lose value during periods of high inflation.

Historically, during periods of inflation, the **stock market** usually has kept pace with inflationary trends by increasing in value. In recognition of this fact, an insurance company selling variable life establishes a **separate account** which consists primarily of a portfolio of **common stock** and other investments.

The premiums from a **variable life insurance contract** are placed in the company's separate stock market account—so, there is considerable **investment risk** to the policy owner and few guarantees.

Due to this element of investment risk, the federal government has declared that variable contracts are securities and are thus regulated by the Securities and Exchange Commission (SEC), the National Association of Securities Dealers (NASD) and other federal bodies.

Federal laws require a mandatory **45-day free-look provision** from the date of policy application for a variable life contract. Also, variable life policy owners have **voting rights**. Under federal securities law, the policy owner is allowed one vote for each $100 of cash value. And the policy owner must be permitted to **convert to**

traditional whole life insurance within 24 months of policy issuance.

At the time of solicitation, variable life **illustrations or projections** may not be based on **assumed interest rates** greater than 12 percent. This prevents both the agent and the policy owner from assuming excessive and **unrealistic rates of return**.

You should ask for a variety of policy performance illustrations at different rates in order to understand a variable life product most clearly. And remember: Interest rates are not guaranteed and historical performance may not be duplicated in the future. If an agent or salesperson relies exclusively—or even heavily—on maximum historical performance, you may want to think twice about the policy.

There are basically two types of variable life insurance: **scheduled premium** variable life and **flexible premium** variable life.

Scheduled premium variable life requires that a **periodic level premium** be paid to keep the policy in force. Because a specific premium will be paid, this type of variable life provides a **guaranteed minimum death benefit** equal to the initial face amount of the policy. Excess death benefit may be paid depending on the performance of the policy's separate account.

> If the portfolio of common stock in the sepa-
> rate account does well, then the variable life
> policy will perform well. However, the policy
> owner is guaranteed a minimum death benefit
> regardless of the performance of the separate
> account.

The **cash value** of the scheduled premium variable life policy is not guaranteed. The values are solely dependent upon the performance of the separate account. Due to this factor, any cash value loan is usually limited to 75 percent of the policy's available cash value.

In most other respects, the scheduled premium variable life contract is very similar to traditional whole life.

Flexible premium variable life is basically **variable universal life**.

Variable universal is a combination of variable life insurance and universal life insurance. The benefits of such a plan are that it combines what are considered the outstanding features of both products. It provides the flexibility of universal life and the hedge against inflation of variable life.

Although this insurance may provide a minimum guaranteed death benefit, most often there is **no guarantee of death benefit** or cash values. It is very difficult for an insurance company to provide a guaranteed death benefit when the amount of premium you will pay is unknown.

So, the performance of this kind of policy is solely based on the performance of the separate account.

Target premiums are fixed in the first year but policy owners, because of the flexible nature of the products, are **not contractually bound** to pay those amounts in subsequent years.

> Target premiums for variable universal life are among the highest in the insurance industry. Since these are the basis for commissions, compensation for selling the product can be higher than for other kinds of insurance. This is something to consider when an agent or broker suggests variable universal.

MORTGAGE INSURANCE

Life insurance to cover the costs of your mortgage is a good idea. However, the **mortgage insurance** sold by lending institutions or mortgage brokers isn't always a good deal. You are often better served by purchasing a regular policy—term or cash value—in the amount of the mortgage from a separate insurance company.

Among the reasons to avoid mortgage insurance sold by lending institutions:

- the lending institutions' policies are designed to guarantee the bank gets paid instead of your survivors;

- the policies appear to be priced competi-

tively—but usually contain clauses that restrict options;

- decreasing term policies usually give the insurance company the right to automatically reduce your insurance.

The right to **keep or reduce** your insurance amount is very valuable and under no circumstances should you allow the company the right to reduce your coverage. Your health may change and you will want to keep the coverage. At that point you don't want the company to be in control of reducing coverage.

GROUP LIFE POLICIES

Employers generally offer **group life insurance** as an employee benefit. This kind of insurance is usually written as one-year term insurance.

The **legal requirements** of group insurance are uniform throughout the majority of states and include the following basic characteristics:

- Most states define a *true* group as having at least 10 people covered under one **master contract.** Some states make allowance for even smaller groups.

- Coverage is generally available **without individual medical examinations.**

- The policy is issued to the **employer,** trust, union, or other association. **Certificates of insurance** are issued to the individual insured.

- The insurance cannot benefit the em-

ployer, trust, union, or other association. It must benefit the covered **employee or member** and any dependents.

- Premiums are based on the experience of the **group as a whole.**

- Premiums can be paid entirely by the policy owner or jointly by the policy owner and the insured employees. If the premium is paid entirely by the policy owner, it is a **noncontributory plan** and all eligible employees or members must be covered. If premium is paid by both the policy owner and the insured employees, the plan is a **contributory plan** and at least 75 percent of all eligible employees or members must be covered.

- Employees can be deemed eligible or non-eligible according to any **legitimate occupational distinction** (salary or hourly status, staff position, time on the job, etc.).

Group life policies have some **special provisions** unique to group insurance. Some of these provisions are the same as those found in policies of individual insurance. Group policies must contain provisions relating to the following:

- **Evidence of insurability.** Individual insurability must be proven if the employee or member joins the plan after the enrollment period.

- **Conversion.** An employee or member must have the right to convert to an in-

dividual policy when the group coverage is terminated because of **termination of employment or the elimination of a class of insured people.**

- **Termination of master policy.** An employee or member must also have the right to convert to an individual policy because the master policy has been terminated.

- **Individual certificates.** These must be issued as evidence of coverage under a master policy.

There are five main types of group life insurance being marketed to eligible groups: group term life, group permanent life, group creditor life, group paid-up life, and group survivor income benefit insurance. Group insurance is also written to include the dependents of the group members.

It is possible for people in **poor health** to receive group insurance benefits because there is no medical underwriting. All eligible participants obtain coverage. But underwriting, the risk selection process, does occur. Insurance companies will consider the risk factors posed by employees as a group—and price the insurance accordingly.

Example: Coal miners will pay more for group life insurance than office workers.

Nevertheless, there are many advantages of purchasing this kind of life insurance. The most important of these include:

- Underwriting is frequently **guaranteed or very easy.**

- Price per $1,000 of coverage is frequently the same for all employees **regardless of age.** Clearly, this is a much better deal for older employees than for younger employees.

- The **convenience** of being able to purchase insurance without a medical exam, having payroll deductions and minimum paperwork makes it very attractive.

> Some employers offer employees the option to purchase additional insurance through the group plan. This can be a big opportunity for people who would otherwise have trouble getting insurance. If this is the case for you, buy all of the group coverage you can.

One disadvantage of group life insurance is that it is usually only **temporary coverage.** An individual member of the group may lose that coverage when he or she leaves the group.

To lessen this disadvantage group term policies must include provisions to provide for conversion to individual coverage. They may also include continuation of insurance provisions, and waiver of premium pro-

visions. Some employers continue group term insurance at reduced amounts for retired workers.

ASSOCIATION GROUP POLICIES

Many **professional associations** (the American Medical Association, CPA Society, State Bar Associations, Engineering Associations, etc.) offer **association group term** to their members.

The quality of these programs is mixed—so it is not possible to generalize, except to caution about certain **common problems** (which may apply generally to all group insurance plans):

- The price of the association group life insurance is comparable to individual policies. So, despite good advertising by many associations, **price is not a real basis for choice**.

- The **underwriting may be lax,** if you have had medical problems, you may get favorable underwriting from association plans.

- **Association membership** is usually precondition of having the insurance. If you think you may not continue your membership or will cancel it upon retirement, you may no longer be eligible for insurance.

- The right to **convert the group policy** to an individual cash value plan is an important benefit. If the conversion option is not available, it may be wise to pursue

an individual plan with conversion rights.

- Quality of insurance company is important. It is wise to demand the same high financial ratings of a group carrier as you would from an individual carrier.

- The insurance company can **cancel the group** at any time. While the company cannot usually cancel an individual policy, it can—and frequently does—cancel an entire association.

- You may have to **requalify** medically if the carrier cancels the group. At that time, you may not be able to qualify and therefore, could be ineligible for insurance.

- Your **rates aren't guaranteed**, since the carrier can increase the rates or cancel the group.

MAIL ORDER INSURANCE

You see the offers on late night television and in senior magazines: An aging celebrity talks assuringly about cheap life insurance available to older people, veterans or those who don't qualify for standard coverage.

> There is no reason to consider this kind of insurance. It is virtually impossible to determine the price, product, contract, caveats and exclusions in such plans without first purchasing the product.

If you choose to purchase insurance through these channels, apply as many principals contained in this book as you can—and good luck.

CONCLUSION

Although universal life policies and other variations were developed to provide **flexibility** in the type of protection that you choose, these policies are sometimes accompanied by a degree of **uncertainty and increased risk**.

They may provide attractive alternatives, but it is important to focus on how these products perform when compared to other alternatives. In the next chapter, we will examine these alternatives further and discuss how to go about choosing the life insurance policy that **best suits you**.

CHAPTER 7

CHOOSING THE RIGHT KIND OF LIFE INSURANCE

INTRODUCTION

Determining what type and amount of life insurance is right for you requires some careful thought. There are over 2200 life insurance companies in North America—and all insurance companies are not the same, despite what some agents or salespeople may tell you. There are big differences among them, differences that could cost you thousands of dollars in needlessly high premiums or limited coverage.

What's more, a number of derivative insurance products are marketed by some aggressive salespeople. These products are usually based on the three major kinds of insurance: term, whole life, and universal. These complex forms are usually designed to fit extremely specialized situations. They often don't make sense for most consumers.

> The insurance industry has undergone some serious changes in the last decade. The kinds of life insurance sold—and the kinds of people selling it—aren't as steady and reliable as they were a generation ago. For these reasons, you need to do some homework before you even consider buying coverage.

In this chapter, we will consider how you can choose the kind of life insurance you need. We'll review the most common kinds of insurance—and the derivatives.

RENTERS VERSUS HOMEOWNERS

The debate over whether term life or whole life is **the better deal** will likely go on as long as there is insurance. People who believe in (and often sell) term swear whole life is a rip-off. People who believe (and often sell) whole life swear that term is the rip-off. Like the Lilliputians in *Gulliver's Travels* who went to war over which end they crack first when eating an egg, both sides may seem obsessed with trivia to you. But there are some **important differences**.

> An old insurance industry rule of thumb holds that people who rent their houses tend to buy term insurance and people who own their houses tend to purchase whole life insurance.

There's some logic behind these conclusions. The factors that influence someone to rent are typically that he or she is:

- short on cash;

- in transition—not settled in job, family or place;

- facing financial uncertainty;

- not in a position to make long-term commitments;

- interested in investing money in other ways.

These are the same reasons people give to explain why they purchased **term insurance** instead of cash value insurance.

Other factors influence people to purchase a home. These typically include:

- belief in owning and building equity,

- focus on long-term thoughts and plans,

- sufficient stability to make commitments,

- a desire to accumulate wealth and build savings,

- a need for tax benefits,

- a desire to accomplish financial goals during working years,

- a desire to pass wealth and assets on to children.

Use the following questionnaire to decide which category of insurance applies best for you.

Available Cash	YES	NO
Does your current cash flow allow you to save money?	☐	☐
Could you save money if you really tried, or is cash just too tight?	☐	☐

If your answers to these questions are "no," then term insurance is your only option.

Available Savings	YES	NO
Are you currently consistently saving every month?	☐	☐
Are you savings as much as you think you could be if you had a systematic plan?	☐	☐

If you answered "no" to the above questions, then the systematic savings feature of cash value insurance may be of interest.

Specific Savings Goals	YES	NO	N/A
Do you need to start or increase your retirement savings plan?	☐	☐	☐
Do you need to start or increase your college savings plan for the children?	☐	☐	☐

If you answered "yes" then the "tax free" accumulation inside a cash value policy may be interesting to you.

Retirement and Tax-Free Incentives			
Are you in a high tax bracket?	☐	☐	☐
Do you plan to work 10 or more years before retiring?	☐	☐	☐

If you answered *yes* to most of the questions in the survey, then **whole life or other cash value life insurance** may be of interest to you. These types of coverage make most sense for people in higher tax brackets and planning to maintain the coverage for more than 10 years.

On the other hand, even the most structured kind of **term life insurance** will offer you a steady price for 10 years but can raise the premium 900 percent or more **if you don't pass a medical exam** at the end of the 10-year period.

> The most important right you have in a life insurance policy is the right to keep the policy in force without restrictions or dramatic premium increases. If the company requires you to pass a medical examination to avoid a premium increase in the future, you have assumed a big risk. You get a discount for taking the risk, but is it worth it?

Some critics of term insurance argue that term insurance companies reduce the premium for a few years so that they can *coerce* you into a medical in the future. This view may be extreme, but there is an element of truth to it.

Many consumers are seduced by **initial low premium policies** that require medical **requalification** to maintain a reasonable premium. To avoid this kind of problem, ask the following questions about any term policy you're considering:

- If you don't pass the medical requalification, what will the premiums be?

- Are they written in the contract? Are they guaranteed?

- If you're required to take and pass a medical exam in order to avoid dramatic increases, how extensive is the exam?

- What standards of underwriting will be applied at that time?

- Will the underwriting standards be the

same for requalification as for new ap-
plicants?

- Will there only be a "pass" or "no-pass"
 standard or will there be a range of rat-
 ings?

If the answers to these questions aren't in writing in
the policy, **get another policy**.

If you're still unclear about what kind of life insur-
ance will work most effectively for you, consider the
following guidelines:

- If you have no need of the insurance for
 more than 10 years, **term insurance** is a
 better choice. If you clearly need it for
 more than 15 years, **whole life or cash
 value** wins the race. If you need it for only
 10 to 15 years, it's a toss-up.

- Don't buy a policy that you are afraid you
 can't continue. Cash value insurance
 only makes sense if maintained for more
 than 10 years.

- The higher your **tax bracket**, the more
 valuable whole life or other cash accu-
 mulating insurance will be—if you prop-
 erly understand it.

- For older people (over 60), term is rarely
 useful because premiums quickly be-
 come unaffordable.

- If you are an equity investor, you can use
 cash value life insurance as the liquid part
 of your total portfolio.

(FINANCIAL COMPARISON FOR 30 YEARS)

Insurance Alternatives for a 40-Year-Old Male

	Term (Plan A)	Blended Term/Whole Life (Plan B)	Whole Life (Plan C)
Insurance Benefit	100,000	100,000	100,000
Annual Outlay			
Year 1	159	1,287	1,884
Year 10	194	1,287	1,884
Year 11	249	1,287	0

	Term (Plan A)	Blended Term/Whole Life (Plan B)	Whole Life (Plan C)
Year 20	525	1,287	0
Total Outlay (Age 40-76)	16,111	46,314	18,840
Ongoing Insurance	0	238,713	160,303
Cash Value	0	174,257	110,038
Annual Lifetime Income	0	17,406	11,038

Plan A: Premium Increases Annually. Insurance ends at age 70.
Plan B: Level Premium.
Plan C: Level Premium Payments for Only 10 Years.
These figures are for illustration purposes only.

SELECT THE BEST COMPANY

Insurance companies are like any other business. Some operate **more efficiently**, some are more disciplined, some screen their insurance pool more carefully—which reduces their **mortality costs**. Some pay **lower commissions** and control overhead costs better.

Selecting the right life insurance company is like selecting the right neighborhood and house. If you pick the right one, your investment will stay steady or even increase. If you pick the wrong one, your investment may loose value.

Focusing on an insurance company before a specific policy may seem like an upside-down approach—but it will save you time, money and confusion.

When you sign an insurance contract, you probably assume that you are buying a **concrete deal with specific terms**. But—in most cases—the insurance company reserves the right to change:

- the premium,
- the death benefit,
- the rate of return (dividend),
- projected cash values,
- mortality charges,

- administration charges,

- treatment of blocks of existing policy-holders.

As a policyholder, you are dependent on the good will, ethics, business judgment and management skills of the company you choose. This comes as a surprise to most people.

Real estate people know that when you buy a home, location is more important than the price. A $100,000 house in one neighborhood may lose its value, in the same time that a $100,000 house in another neighborhood may gain value. Think of an insurance policy as *located* in the company that offers it. An excellent company will be a better buy over time if the premiums are the same. It may even make sense to pay a little more for a good company.

When you select a life insurance company, you are picking the company that you plan to collect from 30, 40 or 50 years from now. Quality plays an important role in long-term stability—no matter what kind of business we're talking about.

The qualities of excellent insurance companies include:

- size,

- financial rating,

- low historical cost performance,

- low death costs (mortality),

- low commissions,

- low administrative costs, and

- strong cash reserves.

Weaker companies will **disguise their problems** by diverting attention away from company financials and focusing on:

- cheap premiums,

- new types of policies and terms,

- easy underwriting,

- special offers,

- short-term price savings instead of long-term value (cash or otherwise), or

- their company's age—rather than size or strength.

Shifty companies and their sales people will also claim that all companies are *pretty good and pretty much the same*. That's simply not true. Always be wary of a **hard-sell insurance agent**. Weak companies usually pay the **highest commissions**—so their salespeople will usually be the most aggressive you encounter.

COMPARING COSTS:
THE BEST AND THE WORST

	THE BEST "A" RATED	THE WORST "C" RATED
INCOME PREMIUM Very little difference	N/A	N/A
INVESTMENT INC RETURN Very little difference	9.0%	9.5%
COSTS MORTALITY Lower rate is better	23.0%	35.7%
SALES EXP Lower cost is better	5.6%	13.2%
OPERATING EXP Lower % is better	3.5%	13.4%
CLAIMS PAYOUT Lower % is better	17.2%	31.2%
SURPLUS RESV How much does it set aside to remain financially strong?	42.7%	19.2%
NET PROFIT/ DIVIDENDS Profits to stockholders, dividends are returned to policyholders	25.2%	0.0%

WHEN TO USE TERM OR CASH ACCUMULATING

You don't have to be a rocket scientist to figure out that a two-seater sports car is not a family car. Similarly, you don't have to have an in-depth understanding of life insurance to **eliminate some options**.

- If you're young and have a family and you're broke, a **term policy** is where you start.

- If you're a young family trying to save money but it's hard to save, a **mix of term and cash value** might be ideal.

- If you're divorced and need to (or are required to) maintain life insurance until your children are grown, consider a **level term** policy for the number of years necessary to fulfill the need.

- If you've decided to start a college savings plan for your children or grandchildren, a **rapidly accumulating cash value** policy might be best.

- If you're in your 40s and realize you need to increase your retirement savings, several types of **cash accumulating** policies will make sense.

- If you're over 60 and need life insurance to pay estate taxes, you'll almost certainly need a **cash accumulating** plan.

- If you're an active investor under 50 and want to accumulate cash for retirement, a **variable life** plan may be of interest because you get to control the investment.

The life insurance industry has become quite creative in the 1980s and 1990s. A number of **combination** and **derivative** coverages developed in recent years answer specific needs.

A caveat: Some first-time buyers of life insurance will be sold one of these combination or derivative packages when their needs really are simpler.

In the rest of this chapter, we'll consider the basic issues addressed by combination or derivative policies.

FAMILY INCOME POLICY

One of the most popular, and perhaps most useful, of the combination life insurance contracts is the **family income** policy. Combining **whole life** insurance with **decreasing term** coverage, this policy provides temporary protection and permanent coverage. The term portion of the coverage provides **monthly income** benefits for the family and the permanent (whole life) part of the policy provides a **lump sum** payment.

Some family income policies split the lump sum payment into two payments. In this case one-half the policy's face amount would be paid to the beneficiary to assist in paying for the funeral expenses and the costs of the last illness. This would then be followed by the specified income payments for a period of years. At the end of the payment period, there would be another lump sum payment equal to one-half the face amount of the policy.

So, a family income policy has two time elements. The family income portion of the policy corresponds to the decreasing term time period. The base part of the policy is usually whole life and thus some degree of protection is provided for the whole of life (to age 100).

The family income policy fulfills the need for **higher amounts of coverage** during the initial child rearing years. When the children become self-supporting the need for protection and coverage is reduced.

FAMILY MAINTENANCE POLICIES

The family maintenance policy consists of a combination of permanent **whole life** insurance plus **level term** insurance. It also consists of a temporary income period plus lifetime protection. The level term part of the policy provides a **monthly income** (triggered by the death of the insured person) and the whole life portion provides the **lifetime protection**.

> The primary difference between the family in-
> come policy and the family maintenance
> policy is the length of the income period.

The insurance industry has developed a **package life insurance** contract to protect all members of a family under one policy, usually termed a *family policy* or *family plan*. Its purpose is to provide minimal amounts of coverage on each member of the family. Usually, most of the premium dollar purchases whole life insurance for the head of the household and term insurance in smaller face amounts is written on the other members of the family.

> Generally, family plans are sold or purchased
> with reference to units of insurance—worth a
> predetermined amount of face value. So, a
> family plan might state that the husband/fa-
> ther has four units of coverage, the wife/mother
> two units of coverage and each child one unit
> of coverage. If a unit was worth $10,000, this
> would mean $40,000 in whole life and $20,000
> and $10,000 each in term life—respectively.

JOINT LIFE POLICIES

Joint life policies are whole life contracts written with two or more persons as named insureds. Most commonly, the policy is issued on two lives with the insured amount **payable on the death of the first in-**

sured only. However, some policies pay on both deaths and even (usually for **business insurance** purposes) pay on the first death and then increase the amount of coverage on the remaining insured or insureds so that the total coverage remains the same.

A variation of the joint life policy is the **last survivor policy.** It pays the insured amount not to the beneficiaries of the first insured to die but to those of the last.

> Usually, a joint life policy will provide a conversion or exchange privilege for the surviving insured whereby that person may continue the coverage on his or her life following the death of the other insured.

MODIFIED LIFE

Modified life is typically a whole life product which is purchased at a **very low premium** for a short period of time (three to five years) followed by a higher premium for the life of the policy. The policy may be a combination of term for the **modified period,** automatically converting to a whole life premium so that premiums are lower than average during the modified period and slightly higher than average (to make up for the early deficit) thereafter.

Generally, this type of policy is sold to people who want whole life but, for the next few years, will be unable to pay the typical premium. The person can thus afford the opportunity to purchase whole life with a modified premium for the initial three to five years of the policy.

Graded premium whole life is similar to modified whole life in that initially the premium is very low. Unlike modified life which has one increase to a higher, level premium for the life of the contract, graded premium policies provide for an increase in premium each year for the first 5 to 10 years of the policy. At the end of this **step rated** premium period, the premium remains level for the life of the policy.

It should be noted that graded premium and modified life policies build cash value—but the amount of the cash value is usually less because of the smaller outlay of premium. Typically, a graded premium policy will have very little, if any, cash value during the graded premium period.

SPLIT-LIFE POLICY

The split-life policy is a combination of a whole life or a term life insurance contract and an **annuity contract**. The savings feature is a retirement annuity to age 65, and the life insurance feature is usually yearly renewable term insurance.

The sale of the split-life policy has not been approved in all states, because it seems to discriminate in favor of those individuals who purchase annuities. Those who do not purchase an annuity along with their life insurance do not receive the same **low cost benefits** as those who do purchase the annuity. The insurance contract may be renewed as long as the annuity premium continues to be paid. The most common amount of coverage found is up to $10,000 of term insurance for each $10 of annuity premium paid.

DEPOSIT TERM INSURANCE

Deposit term insurance is a level term insurance policy that has a much higher premium for the first year than for subsequent years. The **initial premium is significantly higher** than the average premium needed to cover the **cost of mortality** during the term period.

The excess front end premium—the **deposit**—is then set aside to earn interest, and these dollars (deposit plus interest) will be applied to **reduce the premium payments** required in the following years. The premium levels are set so that the entire deposit will be exhausted when the final annual premium is paid. In effect, this arrangement provides a method of paying a portion of the premium in advance.

Example: The annual premium for a 10-year level term policy for a particular insured may be $500 (total outlay of $5,000). The same type of policy may be purchased as a deposit term contract for an initial premium of $2,500 followed by annual premiums of $200 (total outlay of $4,300). The initial deposit and interest are used to make up the difference in premium. Mathematically, the insurance company actually receives an equal amount of premium for these two policies when the time factor and interest earnings are taken into account.

ADJUSTABLE LIFE INSURANCE

Adjustable life is a policy which offers the policy owner the options to adjust the policy's **face amount, premium** and **length of protection** without having to complete a new application or have another policy issued. This kind of insurance introduces the flexibility to convert to any form of insurance (such as from term to whole life) without adding, dropping, or exchanging policies.

Adjustable life is based on a **money purchase** concept. The basic premise becomes not so much which type of policy does a person buy but rather how much premium is to be spent.

> Example: If a 25-year-old applicant states that he or she can afford to pay a $500 annual premium, an adjustable policy may be mostly term the first few years, then a blend of term and whole, then finally a whole policy several years later. By the time the insured is 50 years old and planning for retirement, the same $500 premium would be used for some form of permanent insurance protection with guaranteed cash values.

If the insured makes an adjustment in the policy which results in a **higher death benefit**, proof of insurability may be required for the additional coverage.

INDUSTRIAL LIFE POLICY

The industrial policy is written for a **small face amount**, usually $1,000 or less, and the premiums are payable as frequently as weekly. This coverage derives its name from the fact that it was originally sold in England to the *industrial class* of factory workers.

The industrial policy owner determines how much he or she can pay each week—and the face amount of coverage is determined from this. A company representative will call on the policy owner each week, usually at home, to collect the premium. The policy benefit is usually used to pay for last illness and burial expenses.

This method of distribution is **very expensive** for two reasons. First, the **mortality rates** are higher for in-

dustrial policy owners because these people tend to have higher than average health risks and poorer than average living standards. Second, having the agent collect the premium each week increases **overhead costs.**

The market for industrial life has decreased considerably over the last several decades. Today, industrial life represents about **one percent of life insurance in force.**

Recently, a variation in the industrial life concept known as **home service life insurance** has emerged. Policies are usually modest in size, ranging from $10,000 to $15,000 in face value, and are typically sold on a monthly debit plan (automatic bank draft) or payments by mail.

Most of the **provisions** found in individual life insurance policies are also found in industrial life insurance. However, because the face amount of the policy is so small and the cost of this type of insurance is expensive, certain provisions do not have the same impact on industrial insureds as on individual insureds:

- The application is not required to be part of the policy.

- Medical examinations are not required.

- Cash values do not accumulate sufficiently to provide loans.

- Settlement options do not apply because of limited cash value.

- Suicide provisions are not included in the

policy because of the small benefit amount.

- Nonforfeiture provisions do not allow the cash option until premiums have been paid for five years (compared to three years for ordinary policies).

- Dividends are always used to reduce the premium payment or to purchase paid-up additions.

CREDIT LIFE INSURANCE

The unexpected death of an individual who has **time payment obligations** can create serious problems for his or her family. Credit life insurance provides that, in the event of the death of an insured debtor, out-standing balances are paid off in full.

Credit life insurance can be written on a group basis or in individual credit life policies. It is usually written as a decreasing term type of coverage so the amount of insurance reduces as the amount of the obligation reduces. Level term insurance may also be written which would remain level for the term of the loan. The benefits are payable to the creditor and are used to reduce or extinguish the unpaid indebtedness.

Usually, the individual debtor pays the total premium—even though the creditor is the policy owner. The premium is added to the finance contract amount so that, in effect, the insurance premium is being financed along with the item being purchased.

CONCLUSION

Why is cash value insurance a poor short-term investment? The costs of operations, commissions, marketing, etc., are loaded into the first few years of the policy. Therefore, the cash accumulates slowly at first.

Why is cash value insurance a good long-term investment? The cash accumulates tax-free. Therefore, for people in higher tax brackets who need the insurance for more than 15 years, cash accumulating policies are the most cost effective.

You have to decide on which side of this issue your circumstances place you. That decision will usually tell you whether you need term or cash value life insurance.

But the decision's not always that easy. Specialized policy forms are designed to provide coverage in special situations. These forms can vary from insurance company to insurance company but are designed to help you choose the right kind of life insurance for your specific needs.

CHAPTER **8**

CHANGING FROM ONE KIND OF INSURANCE TO ANOTHER

INTRODUCTION

During the 1980s, there was a term price war and—every year—companies offered lower priced products. Agents would sell company A's policy one year; the next year they'd come back to the same client offering Company B's policy at better rates.

Agents encouraged this **churning** because they received a new **first year commission** every time they sold a new policy. Since these first year commissions were higher than the **renewal servicing commissions**, many agents simply replaced their own policies every two or three years.

As price competition increased, consumers quickly realized that **replacing the old policy with a new cheaper one** every two or three years, they could get a free medical examination and a new cheaper policy.

However, some not-so-bright consumers ended up trading larger benefits for smaller ones or—even worse—paid-up cash value policies for term policies.

In the wake of all this, the insurance companies needed to do several things:

- keep the policyholder paying premiums for a **longer period** (5 to 10 years),

- keep the agents from replacing the policies every two years with **cheaper products**, and

- offer low **attractive prices**.

Clever actuaries found a solution in the arcane laws governing the amounts of money insurance companies have to reserve per $1,000 of insurance. The solution was to offer **level term insurance** for 5, 10, 15, or 20 years. At the end of the level period, the premium would increase like traditional **annual renewable term**.

This solved all of the problems:

- the customer was incentivized to keep the policy for the full level period,

- the agent couldn't easily persuade the customer to change policies, and

- the insurance company found a way to lock in the consumer for a 5, 10, or 15 year period.

Still, **replacement** remains a perilous process.

THE REPLACEMENT GAME

Technically, replacement means **any transaction in which new life insurance or a new annuity is pur-**

chased. It is known—or should be known—to the agent or insurance company (if there is no agent) that, as part of the transaction, the existing life insurance or annuity will be:

- lapsed, forfeited, surrendered, or terminated;

- converted to reduced paid-up insurance continued as extended term insurance, or reduced in value by the use of nonforfeiture benefits or other policy values;

- amended to produce a reduction in the benefits or in the term for which coverage would otherwise remain in force, or for which benefits would be paid; or

- reissued with reduction in cash value.

> Commissions paid to agents for selling a new policy are particularly lucrative. For this reason, unscrupulous agents have persuaded consumers to give up old policies for new ones, even if it was not in their best interests.

Frequently, it is not in the best interest of the policy owner to replace existing life insurance with a new policy. The reasons for this are many:

- new insurance requires the applicant to prove insurability,

- premiums may be higher for a new policy,

- new policy provisions will have to be compiled with such as a new incontestable period,

- the existing policy's provisions may be more liberal than a new policy's provisions, and

- generally, a new policy will not have any current cash values.

Generally, if replacement is involved in any insurance sale or transaction, the agent or broker is required to:

- list all existing life insurance policies to be replaced;

- give the applicant a completed Comparison Statement, signed by the agent or broker, and a Notice to Applicants Regarding Replacement of Life Insurance (a copy of the forms should be left with the applicant); and

- give the insurer a copy of any proposals made, and a copy of the Comparison Statement with the name of insurer that is to be replaced.

At the same time, the duties of the replacing insurance company include:

- making sure that all replacement actions are in compliance with state regulations;

- notifying each insurer whose insurance is being replaced and upon request, furnishing a copy of any proposal and Comparison Statement; and

- maintaining copies of proposals, receipts and Comparison Statements.

The National Association of Insurance Commissioners (NAIC) has adopted a **Model Life Insurance Replacement Regulation**. The majority of states have replacement regulations based on this model.

You should check your state's regulations to learn specific time limits, such as:

- the time within which an agent must supply the applicant with a Comparison Statement,

- the time and manner within which the agent must notify the insurer of replacement activities,

- the time within which the insurer must notify the insurer being replaced that such action is in operation, and

- the time within which the insurer being replaced must respond to the replacing insurer and the applicant.

Also, individual state law specifically outlines the method in which records are to be maintained and the length of time the records are to be made available. A common wording for laws on record keeping is: These records shall be maintained for at least three years or until the next examination of the company by the Insurance Department.

A CASE STUDY OF REPLACEMENT PROBLEMS

Probably the single biggest danger posed by life insurance involves replacement policies that aggressive agents wrongly sell as **cheaper, more cost-effective or broader** alternatives to whatever coverage you're presently carrying. Many of the worst sales abuses never go public—but some more technical cases do shed light replacement problems.

The 1992 Kansas appeals court case *Linda Jean Sonderegger v. United Investors Life Insurance Co.* stands out as a good example.

In January 1975, United Investors issued a **modified premium whole life** insurance policy to Linda Sonderegger as owner and beneficiary. Donald Sonderegger, Linda's husband, was the insured under the policy, which had a face amount of $50,000.

The policy limited United Investors's liability for Donald's death from suicide through the following language:

> If the Insured shall commit suicide while sane or insane within two years from the Policy Date, the liability of the Company shall be limited to the amount of premiums actually paid hereunder.

The policy also contained a **conversion provision** which granted Linda Sonderegger the right to convert the policy on its tenth anniversary into other insurance defined under several options. The options

stated that the new policy would be issued **without evidence of insurability** if the new policy had the same face amount or less as the original policy. The conversion provision also contained the following language:

> If the policy is converted...the suicide clause shall be void in the new policy resulting from such conversion, and the new policy will be incontestable from its date of issue.

In a letter dated November 9, 1984, United Investors notified Sonderegger of the approaching tenth anniversary of the policy and advised her that, pursuant to the policy, she could continue the coverage as an ordinary life plan or convert it to a **decreasing term** insurance plan.

The company further explained that because its new life insurance plans offered greater value for the money, "we are extending to you the option to purchase any policy now offered by our Company up to the amount of your Modified Premium Whole Life Policy without evidence of insurability."

On December 6, 1984, Sonderegger and her husband Donald completed a MPWL Conversion Application. The new policy they sought was called *Vitalife ART*. It had a face amount of $100,000. The application contained the following statement above the signature lines:

> I acknowledge that the coverage provided by [the previous policy] will permanently terminate when the policy applied for above goes into effect.

An **annual renewable term** life insurance policy was issued in January 1985. The face amount of the policy was $100,000. The insured was Donald and the owner/beneficiary was Linda Sonderegger. The policy also contained a suicide exclusion.

In July 1986, Donald Sonderegger died from a **self-inflicted gunshot wound**. In response to her demand for payment of the full $100,000 under the new policy, United Investors notified Linda Sonderegger that it considered only $50,000 of the coverage to be converted and not subject to the **suicide exclusion** clause.

United Investors said that the remaining $50,000 was new coverage. Therefore, it wasn't liable for that amount—because the suicide had occurred within two years of the issue date.

Sonderegger filed suit for the second $50,000.

The trial court entered a summary judgment in favor of United Investors. It found the conversion options contained in the original policy did not allow a conversion to a policy with a greater face value—to do so was, effectively, to **replace one policy with another.**

Sonderegger appealed. The appeals court opened its review by establishing ground rules for considering disputes over **replacement life insurance**:

> The general rule is that where an insurance policy is issued under a conversion option, whether a new, distinct, and independent contract results will depend upon the extent to which the terms of the substituted policy

differ from the terms of the policy containing
the option.

Sonderegger argued that a suicide exclusion in a **converted life insurance policy** had to run from the original policy's date of issue, regardless of any change in the amount of death benefits.

United Investors simply repeated its argument from the trial court—that the second $50,000 was new, replacement coverage. The appeals court considering the case found United Investors's argument compelling. It found the newer policy a **replacement**—and concluded that the insurance company did not have to pay the second $50,000.

CANCELLATION TERMS

Employer sponsored group insurance or association group insurance can usually be canceled at the insurance company's discretion. This isn't usually so for individual policies.

Be careful about trading an individual policy that can't be unilaterally canceled for a group policy that can be.

TERMINATION OF BENEFITS AT A SPECIFIED AGE

There are numerous policies in which benefits are only available for a 10 year period, 20 year period, or to age

70. Make sure you're not trading a long-term policy for one that has more time restrictions.

Cheap premiums may mean hidden restrictions. Many companies offer 10 or 20 year term policies with limited conversion rights.

GUARANTEED RENEWABILITY

This is another standard term you will often see. It means that the policy is **guaranteed to give the option of continuing** insurance at some point in the future. It may be renewable for 10 years, to age 70, to age 100 or for life. The renewing of the policy assures you that the policy cannot be canceled by the company until that future date arrives.

Some unwary people will **trade a policy with guaranteed renewability for one without.** Avoid this at all costs—especially if you're over 40.

REINSTATING LAPSED POLICIES

There are many benefits to reinstating and paying back premiums, instead of applying for a new policy:

- the lapsed policy, because it was written at an earlier date, may have **more liberal contract provisions** than a current policy;

- the **interest rates** on the policy loans may have been offered at a lower rate;

- a policy issued at a younger age most likely has a **lower premium schedule** than one written at your current age;

- if the policy date is more than two years old, **suicide and incontestable clauses** may no longer apply.

CONCLUSION

When your insurance policy no longer meets your needs, it is important to replace a policy that would be disadvantageous to you.

This chapter discussed the roles of the insurance company, agent and policy owner in replacement of a policy and how it is important that you are not persuaded into buying a new policy that is not in your best interest.

> Before you purchase a new policy, know the rules and regulations that your insurance agent must comply with when delivering a new insurance policy.

CHAPTER 9

USING LIFE INSURANCE AS AN ESTATE PLANNING TOOL

INTRODUCTION

Life insurance can create an **immediate estate** for the insured person and provide funds that will help preserve the greatest amount of value in the estate. The field of **estate planning** is very complicated. It requires expertise in the areas of wills, taxes, law and life insurance.

In a nutshell, the object of estate planning is to avoid lengthy—and expensive—**probate**. Although most people have heard the term *probate* and some have experienced it, the definition eludes them. In its most simplified form, probate is the process of:

- viewing and understanding a will;

- determining the location and valuation of all properties;

- determining creditors and paying them;

- determining the identity of heirs;

- resolving controversy between concerned parties;

- paying the agent and attorney for probate fees;

- filing and paying current and past tax returns;

- appointing guardians, if necessary;

- appointing money management for minors, if necessary; and

- distributing any remaining property.

A long probate can cause all kinds of problems—including big **tax liabilities**.

Federal estate tax is a tax on the right to transfer property. It is based on the fair market value of your property and is usually due within nine months of death. The tax must be paid before your beneficiaries receive their inheritance.

(As we've seen before, this tax does not apply to insurance proceeds—only the rest of the things you leave to people when you die.)

THE ROLE OF WILLS AND TRUSTS

One of the biggest reasons that people create **wills and trusts** is to eliminate any family conflict regarding the distribution of money.

Example: Barry and Iris have children ages 2, 12, and 18. They are in their 40's. The distribution of assets needed to include that money be available to the guardians monthly for normal expense and also, a lump sum for college. Monies remaining would be distributed equally when each child reached the age of 21. Iris was concerned that no one particular child feel less important than the others. She and her husband decided that, at age 21, the children were to receive 10 percent of their designated lump sum. This required a document which set out the terms for paying out the money in the right way. Simply said, that money is an estate and that document is a trust.

DISTRIBUTING THE ESTATE

The first step in the estate planning process should be an **ongoing analysis** of your needs and objectives with emphasis on the changing needs of your beneficiaries and what property is, was and will be part of the estate.

This process is important because the needs and objectives of an estate are constantly changing. What is true of an estate plan today may certainly not be valid tomorrow.

There are two methods of distributing the estate; inter vivos transfers or testamentary transfers.

Inter vivos transfers are made while the estate owner is still alive. **Testamentary transfers** are made by will after the death of the estate owner. More specifically, transfers can be made as wills, gifts, trusts or policy ownership under rights of survivorship.

A TRUST AS BENEFICIARY

A trust is formed when the owner of property (the grantor) gives legal title of that property to another (the trustee) to be used for the benefit of a third individual (the trust beneficiary). This **fiduciary relationship** allows the trustee to manage the property in the trust for the benefit of the trust beneficiary only. The trustee legally must not benefit from the trust.

When a **trust is designated as the beneficiary** of a life insurance policy, the policy proceeds provide funds for the trust. Upon the death of the insured person, the trustee administers the funds in accordance with the instructions set forth in the trust provisions.

The way the trust's property is managed is often left up to the trustee, leaving the **trust beneficiary** powerless to intervene if the trust is poorly managed. Also, the trustee may not provide resources for the trust beneficiary as he or she or even the grantor would have wanted; the trust beneficiary must request resources from the trustee, he or she cannot make free use of the property in the trust.

Trusts frequently own policies, as well—especially when avoiding estate taxes is an important priority.

THE INSURED'S ESTATE AS BENEFICIARY

An insured person's estate can be named as beneficiary of an insurance policy. An insured person who is also the policy owner may direct that the policy proceeds be payable to his or her executors, administrators or assignees. Such a designation might be made in order to provide funds to pay **estate taxes, expenses of past illness, funeral expenses, and any other debts outstanding prior to the settlement of the estate.**

> Designating your estate as beneficiary aids in the settlement of the estate by avoiding the need to sell other assets of the estate to pay these last expenses.

On the other hand, it's sometimes not desirable to name the estate as beneficiary because the insurance proceeds are then **subject to the claims of creditors.** This situation may not be what you intend when naming the estate as beneficiary.

One of the unique features of life insurance is that the life insurance proceeds are exempt from the claims of the insured person's creditors as long as there is a named beneficiary **other than the insured person's estate.** Even the cash value of a life insurance policy is generally protected from creditors.

ISSUES OF INSURANCE BENEFITS GOING TO CHILDREN

The typical upwardly mobile family has **several hundred thousand dollars of life insurance**. If both parents were killed together, the children inherit the total estate and the life insurance cash on their eighteenth or twenty-first birthday, depending on the state.

Most children are not prepared for this responsibility. Some of the typical problems young people fall into are that:

- they may squander the money;

- they may marry, get divorced and lose half of the inheritance in a divorce settlement;

- they may entangle the money in poor investments, judgments, IRS liens, etc.

> To allow hundreds of thousands of dollars to be controlled by inexperienced decision makers is irresponsible estate planning. A better approach is to structure the distribution. This allows the inheritance to coincide with greater maturity.

If insurance proceeds are held in a trust, they are less likely to be included in a divorce settlement, bankruptcy, or lawsuit. While these unhappy events can happen at any age, they're more likely to be more costly when they happen early. Hopefully, by the time a child

has reached his or her 30s, he or she has become more aware of risks.

As we've seen, if you make arrangements for the proceeds of insurance or other assets to be put into a trust, a trustee will manage the funds.

Example: You designate your brother as the trustee of your estate because he is financially prudent and reliable. He will have a set limit (chosen by you) of monthly funds to accommodate your children's personal needs and expenses. You can also designate other amounts to be used for special needs as the children grow—such as buying a car, going to college, or getting married.

The person you designate to manage the money is not necessarily the person you have to choose to raise your children. You may know a person who is great at financial matters but not good with children. You also may know someone who would be perfect with children but unable to afford it. You can solve this kind of problem by choosing different people for different tasks.

A caveat: In most states minors are under court supervision until they reach a legal age. In some states, the proceeds of your estate may be waylaid in a court-imposed custodianship until your child reaches 18 or even 21 in some states. To avoid this, you can leave your proceeds to a living trust created for the benefit

of your minor beneficiaries. By designing and impos-
ing this trust your proceeds will avoid probate.

INSURANCE PLANNING FOR THE LARGER ESTATE

So-called *larger estates* are those the IRS targets for
estate taxes. These include the estates of an individual
with assets (including life insurance) in excess of
$600,000 or a married couple with assets (including
life insurance) in excess of $1,200,000.

Typically, the estate asset balance is not liq-
uid. The assets may be in the form of home,
real estate, business interests, pension funds,
etc. But this kind of estate can be structured
to be income tax free and estate tax free. In-
surance premiums can be planned, budgeted
and made estate tax deductible.

The following chart traces the tax schedule for larger
estates.

If Your Current Individual Taxable Estate Is:	At Death You Owe Uncle Sam:
$250,000	$ 0
300,000	0
400,000	0
500,000	0
750,000	55,500
1,000,000	153,000
1,250,000	255,000
1,500,000	363,000
1,750,000	475,500
2,000,000	588,000
2,500,000	833,000
3,000,000	1,098,000
3,500,000	1,373,000
4,000,000	1,648,000
5,000,000	2,198,000

THREE RULES TO SAVE MILLIONS

Rule #1: Gifts that reduce the size of your estate are reducing the tax. Therefore, **gifts are estate tax deductible.** Conclusion: Give away as much as you can comfortably afford during your lifetime gifts and annual gifts.

Rule #2: Pre-paying estate tax using **tax-advantaged life insurance** is substantially more cost effective and lower risk than deferring the tax. Conclusion: Purchase estate tax free life insurance, the earlier the better.

Rule #3: Relinquishing control through various as-set transfers and trust planning is a necessary **shift in thinking** in order to get the full benefit of rule number 1 and rule number 2.

Sam and Ida Billings are approaching 60. After successful real estate investment careers, they have decided to focus on maximizing their children's and grandchildren's inheritance.

They estimate their net worth to be $6,000,000—and most of this is tied up in real estate. They believe the value of their holdings will increase and they have plenty of cash flow to retire. They want to apply rule number 1 to reduce their estate through lifetime and annual gifts.

Sam and Ida can give $600,000 in non-cash assets each during their lifetime—for a total of $1,200,000. They decide to gift (this is a common estate-planning term) real estate property with the greatest potential for appreciation.

They had recently purchased an apartment building valued at $1,200,000. By giving their children the property, they have shifted $1,200,000 out of their estate and shifted all of the future growth to their children.

In the years after Sam and Ida started their estate planning, local commercial real estate tripled in value. The $1,200,000 million in property was soon worth $3,600,000—and the rental income going to their children kept pace with inflation. What's more, the gift of $1,200,000 million reduced the growth of Sam and Ida's estate by $2,400,000—that meant more than $1,000,000 of estate taxes saved.

Any individual can gift up to $10,000 per year per person. Gifts in excess of this $10,000 annual capital require that a gift tax return be filed.

Therefore the Sam and Ida may give $10,000 each to each child for a combined gift of $20,000 per child. With two children, the Billingses can gift $20,000 times two—for a total of $40,000 annually—without incurring any gift tax. And gifts are not restricted to children; they can be made to family members, friends, enemies, grandchildren, charities, etc.

Sam and Ida were ready to begin their annual gifting program when their attorney suggested that they could **leverage** the gifts with life insurance.

Their attorney estimated that the estate taxes on a $6,000,000 estate would be approximately $3,000,000 (since they had already gifted the $1,200,000 asset, the tax was applied to the full $6,000,000). He posed three options to pay the taxes:

- **Forced Sales to Raise Cash for Taxes.** In order to get $3,000,000 of cash for taxes, they would be forced to sell more than half of their entire real estate holdings. He explained that if the market was depressed, it could be even more costly to sell. In addition to the forced sale of prime properties, Sam and Ida would lose the future income on real estate, the depreciation and future appreciation for their children. This was quite upsetting since they had planned to pass the real estate to their children for their future.

- **Borrow to Raise Cash for Taxes.** An alternative to selling the properties would be to borrow at current rates. The Billingses calculated the cost of borrowing, the long-term debt service and lost income and did not like that option.

- **Pre-pay Estate Tax with Annual Gifts to Children.** The third alternative was to use the gifts to the children for purchasing life insurance to pay the inevitable tax. The gifts reduced the estate, and by having the children purchase the life insurance on Sam and Ida, the proceeds of the insurance would be income tax free and estate tax free. This was their best solution.

ISN'T LIFE INSURANCE ALWAYS TAX FREE?

Despite what we've said before, the answer here is only a qualified *yes*. There are some frequent basic misunderstandings about the tax free nature of life insurance.

Death proceeds pass to a spouse income and estate tax free (as can all other assets). If the insured person owns the policy upon death, the death benefit is included in the taxable estate (just like all other assets). If children or a trust own the policy, then neither the policy, cash value, nor death benefit is included in the taxable estate.

If your life insurance proceeds are left to a trust for your children in a will, the probate court will probably become involved with the proceeds. Wills and trusts created within wills are always under jurisdiction of the local probate court.

Probate can also be avoided by properly **owning assets**, by properly **designating life insurance proceeds**, by properly **designating the beneficiaries** of employee fringe benefits, and by creating and funding a **living trust**.

THE UNFUNDED IRREVOCABLE LIFE INSURANCE TRUST

The **unfunded irrevocable life insurance trust** is an estate and income tax planning tool for use in solving a variety of problems. It can be used to:

- protect and preserve assets;

- manage assets professionally where the beneficiaries may be unable, by way of disability, minority, or lack of expertise, to manage the assets adequately;

- avoid probate (court supervision of the property);

- provide a source of estate liquidity by allowing the trustee to buy assets from or loan assets to the grantor's estate;

- create tax exempt wealth; and

- save taxes in general.

It accomplishes the last two points by:

- lowering or freezing the value of an es-
tate by the grantor divesting himself of
ownership of the property; and

- passing estate taxes by keeping the prin-
cipal out of the estates of grantor and the
grantor's spouse.

LIVING TRUSTS

Historically, trusts of any kind were considered a tool
for the rich to avoid tax burdens. But living trusts have
become a standard planning technique for millions
of Americans to **avoid probate** and organize their af-
fairs.

If you complete the beneficiary portion of your insur-
ance application as *estate*, your insurance proceeds will
go through probate. However, life insurance proceeds
that are **payable to adult beneficiaries or living trusts**
escape the process of probate.

CONCLUSION

A simple estate with limited assets and one with no
controversy may be **probated in one to two years**.
However, properties, businesses, multiple beneficia-
ries and family conflicts cause probate to be an ex-
pensive, long and drawn-out process. The primary
complaints against the probate system are that it is

public, time consuming, expensive, and puts control in the hands of the courts.

A **revocable living trust** eliminates the long drawn out time and expense of probate. Revocable living trusts are created during one's lifetime (hence living) and are revocable (can be changed). The revocable can be thought of as a pot into which you put property, life insurance or any other assets. These assets can be put into the trust during lifetime or upon death.

If you're concerned about having enough money to pay any estate taxes that the Feds will levy against the things you want to leave heirs, you should consider setting up an unfunded irrevocable life insurance trust. This mechanism allows you to move some cash out of your estate and use it to leverage protection by means of a life insurance policy that benefits your estate.

Just make sure you don't have any angry creditors roaming at large when you pass on.

CHAPTER **10**

USING LIFE
INSURANCE AS
AN INVESTMENT
TOOL

INTRODUCTION

In May 1994, North Carolina Insurance Commissioner Jim Long announced an out-of-court settlement with the Metropolitan Life Insurance Co. over **deceptive sales tactics** used by some of the company's agents. The agreement called for Met to pay more than $1.2 million in fines and make full restitution to affected consumers.

> The dispute centered on the misrepresentation of whole life insurance policies as retirement products. Rather than setting up retirement plans, many Met clients were in fact buying life insurance policies.

"Our investigation concluded that some Met Life agents were deliberately obscuring the fact that they were selling life insurance by calling the policies *retirement plans*. We believe that insurance consumers

have the right to know what they're buying and we hope this settlement sends the message that slippery sales tactics have no place in North Carolina," said Long.

The agreement also detailed an extensive accountability and compliance plan to assure that the deceptive practices did not recur in the future.

Similar agreements with Met Life were reached with regulators in more than 40 other states through the National Association of Insurance Commissioners.

LIFE INSURANCE AND RETIREMENT PLANNING

Life insurance and related annuity products are frequently used to provide the funding for **retirement plans** and other types of plans. Some of these plans may also be funded with other products such as mutual funds, certificates of deposit, stocks and bonds, cash held in bank accounts, etc.

A **retirement income insurance policy** accumulates a sum of money for retirement while providing a death benefit. Upon retirement, the policy pays an income such as $10 per $1,000 of life insurance for the insured's lifetime—or for a specified period. Once the cash value in the policy becomes greater than the face amount, that cash amount becomes the death benefit.

Retirement plans that include insurance and other corporate and individual plans may be described as **qualified** or **nonqualified**. All plans must be in writing and be communicated to the participants—beyond these similarities, there are many differences.

Some of the characteristics of qualified plans include:

- the plan must be **filed and approved** by the IRS;

- the plan **cannot discriminate** as to participation (all eligible employees must be included);

- the plan is usually established by an employer for the **benefit of employees** (there are a few exceptions);

- the employer will receive a **tax deduction** for plan contributions;

- employer contributions on behalf of the employee are generally **excluded from the employee's gross income**—no tax is due until benefits are actually distributed to the employee; and

- investment income realized by the plan is **tax deferred** until it is received by the plan participants.

Some of the characteristics of nonqualified plans include:

- the plan is **not filed** with the IRS;

- the plan may **discriminate** as to participation—it may be selective as to who is covered; and

- the employer does not receive a current **tax deduction** for any contributions made.

The fact that a nonqualified plan is not approved by the IRS does not imply that it is illegal or unethical. A nonqualified plan is a **legal method** of accumulating money for retirement funds and other purposes.

> **Example:** A person buys an individual annuity for the purpose of accumulating his or her own retirement benefits. When this person pays the annuity premium or payment, there is no tax deduction for the payment of the premium. The annuity is not filed with the IRS.

Pension plans and other qualified plans may include **incidental life insurance** benefits, but these must be incidental to the purpose of the plan. The primary purpose of the plan must be to provide retirement benefits.

In order to stay within the requirements established by the IRS, qualified plans must satisfy the **incidental limitation rule**, which requires that the cost for life insurance benefits provided by a pension plan (or profit-sharing plan) must be **less than 25 percent** of the cost of providing all benefits under the plan.

Generally, the cost for insurance protection under a pension or profit-sharing plan is **taxable as income** to the employee to the extent that any death benefit is **payable to the employee's beneficiary** or estate. The cost for any protection for which the proceeds are payable to and may be retained by the plan, trustee or employer is **not taxable** as income to the employee.

Example: An executive insured under a key person life policy does not have to pay tax on the cost of that coverage.

RETIREMENT OPTIONS WITH CASH VALUE

When you retire, you can use a **cash value** life insurance policy in several ways. You can borrow cash values or annuitize payment plans. Both will allow you to use your money for retirement, but each has distinct pros and cons which have to be assessed individually.

If you have accumulated cash value in a life insurance policy when you retire, you can begin withdrawing the money on a **tax free basis**. On the other hand, money that you withdraw from qualified retirement plans like Keoghs or IRAs will be **taxed as income**.

Borrowing allows you to avoid income taxes on the **income borrowed**. This is the good news. However, if you borrow all of your cash value and the policy terminates, you will be hit with **capital gains** tax on the growth in excess of premiums—for money you spent years ago. That's the bad news.

This kind of capital gains tax can be a nasty surprise at age 80 or 85, when most people are busy worrying about health coverage or estate taxes.

Depending on the individual policy characteristics (the crediting rate, the dividend, etc.) and the actual amount you decide to withdraw, you may be able to avoid paying back a **policy loan**. If you carefully keep enough cash in the policy to keep it in force, upon your death the life insurance proceeds will pay off the loan.

A caveat: Be very careful in what rates you assume when figuring how much money you can take out. Overzealous agents will sometimes show illustrations leading to a big retirement benefit. You have to remember that illustrations are based on the **assumption** that the company will continue to credit the cash value of the policy at a **certain rate**.

> Many people lost a lot of money on these investments in the 1980s, when interest rates fell and policies weren't performing the way they expected.

Perhaps the highest-profile failure of any life insurance company in recent years was the 1991 insolvency of California-based Executive Life Insurance Co.

Executive Life had invested heavily in junk bonds and other **high risk securities** to finance the high interest rates it had promised policyholders. When the junk bond market crashed, Executive Life became technically **insolvent**—even though it was still paying claims.

When California insurance regulators seized Executive Life, its policyholders didn't know how much of their money they would ever get back. Indeed, regulators remained unable to sort out the company's liabilities, making it difficult for them to calculate how far Executive Life's remaining assets—plus money promised by several competing rescue plans—would go.

Most policyholders ended up getting **close to the full value** of their policies; but some holders of large policies (and tricky investment vehicles like **guaranteed investment contracts** and **single-premium deferred annuities**), which weren't completely covered by state insurance guaranty funds, got less than 70 percent of the face amount of their policies.

ANNUITIES

Annuities are not—strictly speaking—life insurance; but they are often sold by life insurance agents, so a basic understanding of how they work may be useful.

Life insurance is designed to protect against the risk of premature death. Annuities are designed to protect against the risk of living too long. Annuities are sometimes also called **upside down life insurance**.

The basic function of an annuity is to **liquidate a sum of money** systematically over a specified period of time. An annuity contract provides for a **scheduled series of payments** that begins on a specific date—such as when the recipient reaches a stated age—or a contingent date—such as the death of another person. The payments continue for the duration of the recipient's life or for a fixed period.

> Usually, but not always, an annuity guarantees
> a lifetime income for the recipient.

The **annuitant** is the insured, the person on whose life the annuity policy has been issued. As is the case with life insurance, the owner of the contract may or may not be the annuitant. Unlike insurance, though, the annuitant is in most cases also the **intended recipient** of the annuity payments.

> Depending on the type of annuity and the
> method of benefit payment selected, a ben-
> eficiary may also be named in an annuity con-
> tract. In these cases, annuity payments may
> continue after the death of the annuitant for
> the lifetime of the beneficiary or for a speci-
> fied number of years.

There are two principal types of annuities: **fixed** and **variable**.

A fixed annuity is a fully **guaranteed investment contract**. Principal, interest and the amount of the benefit payments are guaranteed. Fixed annuity payments are considered part of the insurer's general account assets (the conservative investment portfolio, not the stock market one).

There are **two levels of guaranteed interest**: current and minimum. The **current guarantee** reflects cur-

rent interest rates and is guaranteed at the beginning of each calendar year. The policy will also have a minimum guaranteed interest rate—such as 3 percent or 4 percent—which will be paid even if the current rate falls below the policy's guaranteed rate. The **minimum guarantee** is simply a predetermined lowest rate.

A variable annuity, like variable life insurance, is designed to provide a **hedge against inflation** through investments in a separate account of the insurer consisting primarily of common stock. A variable annuity is not a fully guaranteed contract. However, either a fixed or a variable annuity can guarantee **expenses and mortality.**

> Any expense deductions made to annuity benefits are guaranteed not to exceed a specific amount or percentage of the payments made. And, as long as they're reasonable, these expenses can be worth absorbing. The guarantee of mortality provides for the payment of annuity benefits for life.

Variable annuities may be purchased in the same way as fixed annuities—single premium immediate or deferred and periodic payment deferred contracts.

Also, variable annuities include a variable premium feature, known as a flexible premium deferred annuity (FPDA) contract. Variable annuities offer the same annuity options for settlement of the contract as fixed annuities. Both types of annuities are primarily used as retirement vehicles.

A variable annuity poses several other unique issues:

- If the portfolio of securities performs well, the separate account performs well and the variable annuity—backed by the separate account—will also do well. Due to this dependence, there is **investment risk** to the annuitant. There is no guarantee of principal, interest or investment income associated with the separate account.

- As evidence of the annuitant's participation in the separate account, **units of the trust** are issued. This is very similar to shares of a mutual fund which are issued to mutual fund investors. During the accumulation period, these units are identified as accumulation units. Both the number of the units and the value of these units will vary in accordance with the amount of premium payments made and the subsequent performance of the separate account.

Example: Jan invests $100 per month in her variable annuity. On the day the insurer received her $100 payment, the value of an accumulation unit was $10. Thus, Jan is credited with 10 additional accumulation units.

- When the annuitant reaches the annuity period, these **accumulation units** are converted to **annuity units**. The number

of annuity units remains constant. No further money is being contributed to the annuity; thus, there is no further increase in the number of annuity units.

However, the value of the annuity units will vary in accordance with the daily **performance of the separate account.** Accordingly, during the annuity period, benefit checks issued to the annuitant will vary depending on the value of the annuity units at the time the monthly check is issued.

Occasionally, an annuitant may decide that it is in his or her best interests to purchase an annuity which offers some guarantees but also offers protection against inflation. This type of annuity is usually identified as a **combination or balanced annuity.**

A single premium or single payment annuity is usually purchased by making **one lump sum payment.**

Example: You cash in a 20-year-old cash value life insurance policy soon after you retire. This generates a sizable lump sum of cash—say, a little over $100,000. You can use the cash to buy a single premium annuity that creates income for you and your spouse, if you should die first.

WHEN AN ANNUITY PAYS

If you buy an annuity with a single payment, the benefits may begin immediately or they may be deferred.

If you buy an annuity with a series of periodic payments, then the benefits will be deferred until all payments have been made. (This second kind of annuity is commonly called a **periodic payment deferred annuity.**)

There are two periods of time associated with an annuity: the **accumulation period** and the annuity or **benefit period.**

The accumulation period is time during which the annuitant is **making contributions or payments** to the annuity. The interest paid on money contributed during this time is **tax deferred.** The interest earned will be taxed eventually—but not until the annuitant begins to receive the benefits.

Annuity **settlement options** are the provisions of the annuity. Generally, when the annuitant decides to take money from the annuity, an annuity option will be selected as a method of disposing of the annuity's proceeds. It is not unusual for an annuity option to be elected at the time of application.

If you bought a single payment deferred straight life annuity, you would own an annuity, purchased with a single payment, which will provide a pay out for life. Even if an annuity option is elected at the time of purchase, it may (and probably will) be changed at the annuity period to reflect your changing needs. These changes usually have something to do with retirement or the death of a spouse.

The amount of **money available** during the annuity period is determined by the annuity option selected, the amount of money accumulated by the annuitant and the life expectancy of the annuitant.

A **life only** or **straight life** option provides for the payment of annuity benefits for the life of the annuitant with no further payment following the death of the annuitant. There is a risk to the annuitant in the fact that he or she must live long enough once the annuity period begins to collect the full value. If an annuitant dies shortly after benefits begin, the insurance company keeps the **balance of the unpaid benefits**.

> This option will pay the highest amount of monthly income to the annuitant because it is based only on life expectancy with no further payments after the death of the annuitant.

A **refund** option will pay the annuitant for life—but, if he or she dies too soon after the annuity period begins, there may be a refund of any **undistributed principal** or cost of the annuity.

The refund may take the form of continued monthly installments (an **installment refund annuity**) or it may be in one lump sum (a **cash refund annuity**), whichever has been elected by the annuitant.

> This option assures the annuitant that the full purchase price of the annuity will be paid out to someone other than the company issuing the annuity.

If you live well beyond **average life expectancy**, then all of your investment in the annuity will probably have been paid and there will be no refund.

Life with period certain is basically a straight life annuity with an extra guarantee for a certain period of time. This option provides for the payment of annuity benefits for the life of the annuitant but, if death occurs within the period certain, annuity payments will be continued to a survivor for the balance of that period.

> The period certain can be for just about any length of time—5, 10, 15 or 20 years. Most often, the period selected is 10 years because 10 years is approximately the average life expectancy of a male who retires at age 65. Thus, an annuitant retires at age 65, selects life with 10 years certain and dies at age 70, his survivor will continue to receive the monthly annuity payments for the balance of the period certain (five more years).

The **joint-survivor** option provides benefits for the life of the annuitant and the life of the survivor. A stated monthly amount is paid to the annuitant and, upon the annuitant's death, the same or a lesser amount is paid for the lifetime of the survivor. The joint-survivor option is usually classified as **joint and 100 percent survivor, joint and two-thirds survivor or joint and 50 percent survivor.**

The joint-survivor annuity option should be distinguished from a **joint life annuity,** which covers two or more annuitants and provides monthly income to each annuitant until one of them dies. Following the first annuitant's death, all income benefits cease.

CALCULATING GUARANTEED INTEREST RATES

Premiums or payments made during the accumulation period earn a guaranteed return on a tax-deferred basis. There are two ways to calculate **guaranteed interest** paid on these contributions.

The guaranteed purchase rate is the **minimum interest rate** that is guaranteed for the life of the contract. This will be a fairly modest amount—such as 4 or 5 percent. This is the minimum return which will be paid even if the current annual rate falls below the guaranteed rate.

Thus, **deferred annuities** guarantee a minimum interest rate which contributions will earn. Since the guaranteed rate is less than prevailing interest rates,

the insurer will often credit excess interest on the contract.

Excess interest is calculated based on how much the insurer has earned through its investments. If the insurer considers all of its invested reserves and net investment earnings over a relatively long period of time, the interest rate calculation is said to be made based on the **portfolio method**. If the insurer instead considers portions of its invested reserves over a shorter period of time the interest rate calculation is based on the **tier method**.

ANNUITIES AND RETIREMENT PLANNING

Most often, the primary purpose of an annuity is to provide **retirement income**. Like life insurance policies, annuity contracts may include **nonforfeiture provisions** to protect the contract holder from total forfeiture or loss of benefits if he or she stops making the required periodic payments, and surrender charges, or penalties for **cashing in** the annuity before the pay out period begins.

Annuities may be purchased on an **individual basis** to help solve individual retirement needs. In this case, the annuitant is the owner of the annuity. Often, annuities are purchased on a group basis covering a number of annuitants typically in an employment situation.

Group annuities are often used to fund an employer-sponsored retirement plan, with the employer as the contract owner. If the annuitant dies during the accumulation period, the money accumulated will be paid to a survivor.

A common illustration is the **annual premium retirement annuity** contract, in which the total accumulation is calculated based on an annual premium, an assumed interest rate and retirement age (usually 65).

During the accumulation period, the annuity contract is very **flexible** in that the annuitant may make payments or not make payments. In addition, the annuitant has **withdrawal options** whereby the money accumulated can be withdrawn totally, or in part, during the accumulation period.

Annuities may be used to fund **individual retirement accounts** (IRAs), in which case premium payments may be **tax deductible**. But, in this application, there are more restrictions on withdrawals (including tax penalties for withdrawals before age 59).

CONCLUSION

There are few guarantees associated with a variable annuity or other insurance-related investment vehicles.

These contracts will usually guarantee that **expenses** chargeable will not exceed a specific amount or percentage. In addition, they may also guarantee **mor-**

tality—which means a benefit check will be guaranteed for the life of the beneficiary or annuitant. However, these investment tools do not guarantee the amount of the benefits at retirement nor do they guarantee principal or interest.

Considerable controversy has raged over the regulatory issue of whether variable annuities are really **insurance products** or **equity investment tools**. This is generally true of all investment-type insurance products.

Buying life insurance or annuities as investments may make sense to some people as they plan for their retirement. If you're going to use these tools, though, you should think of them as an addition to your basic income-replacement life insurance coverage. In most cases, the investment-type policies entail a degree of risk—either in what you pay in or what you can take out—that makes them a shaky foundation for your essential needs.

RELEVANT TAX
ISSUES

INTRODUCTION

Generally, life insurance proceeds are received **federal income tax-free** if taken in a lump sum. This is true whether the policy is an individually owned contract or a business owned policy. Thus, a beneficiary pays no federal income tax on life insurance proceeds and neither does a corporation.

If the life insurance proceeds are taken other than in a lump sum by the beneficiary, part of the proceeds will be tax-free and **part will be taxable.**

The basic concept is that the principal (face amount) is returned tax free. However, the **installment** received is part principal and part interest. Therefore, the interest portion of the installment is taxable. **All interest is taxable as income.**

Federal **estate tax** is a tax on the transfer of property upon the death of an individual, and may range from 0 percent to 55 percent of the adjusted growth estate. Life insurance proceeds are subject to **inclusion in the deceased's estate** for federal estate tax purposes if:

- the estate was the **named beneficiary,**

- the deceased was the **policy owner,** or

- the deceased **transferred the policy** to another person within three years of death.

> Thus, a corporate-owned life insurance policy on the company's president with the corporation as the president's beneficiary would not be included in the deceased president's estate since the corporation was the owner and beneficiary.

TAXES AND LIFE INSURANCE PREMIUMS

Premiums paid for life insurance are generally not tax deductible. For individuals, they are considered a **personal expense** and therefore not deductible.

When businesses buy life insurance to **perpetuate the continuation of the business,** the premiums are considered to be a capital investment and—for this reason—not deductible. However, when a business buys group term insurance for its employees, premiums are generally considered a **necessary business expense** and are deductible. Employer contributions for permanent life insurance are treated as taxable income of the employee.

MINIMUM DEPOSIT INSURANCE

Minimum deposit life insurance is a high cash and loan value whole life form, usually offering a loan immediately upon payment of the first premium (instead of at the end of the first year). Such policies were devised in the late 1950s to take advantage of the fact that, at the time, Internal Revenue allowed the **interest paid on a policy loan** to be deducted in full for income tax purposes.

Since that time, however, Internal Revenue has placed **restrictions on the interest deduction** when the loan is to finance insurance so that the popularity of the form has diminished.

A **third party ownership** arrangement usually offers a tax advantage to the insured person. If the insured person has no incidence of policy ownership, then the proceeds would not be included in his or her estate—thereby possibly reducing the federal **estate tax liability.**

TAX AND TRANSFERS

Life insurance proceeds may not be exempt from income taxes if the benefit payment results from a **transfer for value**. If the benefits are transferred under a beneficiary designation to a person in exchange for valuable **consideration** (whether it be money, an exchange of policies, or a promise to perform services), the proceeds would be taxable as income.

Taxation under the transfer for value rules does not apply to an **assignment of benefits** as collateral security, because a lender has every right to secure the interest in the unpaid balance of a loan. Nor does it apply to transfers between a policy owner and an insured person, transfers to a partner of an insured, transfers to a corporation in which the insured is an officer or stockholder, or transfers of interest made as a gift (where no exchange of value occurs).

THE EFFECTS OF SURRENDER

If a policy owner **surrenders the policy** for its cash value, some of the cash value received may be subject to ordinary income tax if it exceeds the sum of the premiums paid for the policy (this is known as the Cost Recovery Rule).

> **Example:** Mary surrenders her whole life policy and receives $5,000 in cash. Total premiums paid into the policy were $4,700. Mary owes federal income tax on $300.

In accordance with section 1035(a) of the Internal Revenue Code, certain exchanges of insurance policies (and annuities) may occur as **nontaxable exchanges**. Generally, if a policy owner exchanges a life policy for another life policy with the **same insured and beneficiary** and a gain is realized, it will not be taxed under section 1035(a).

Dividends are considered to be a return of excess pre-

mium paid by the policy owner. They are not included as income for tax purposes. However, **interest earned on dividends** and accumulated by the insurance company or paid to the policy owner is taxable in the year received.

In November 1988, Congress passed the **Technical and Miscellaneous Revenue Act (TAMRA)** which makes any withdrawal, loan, or collateralizing of the cash in certain policies taxable. In fact, depending on the policy owner's age, the amount may be **taxable and subject to a 10 percent penalty**.

In order to avoid the taxation and subsequent penalties, the policy owner must limit his or her investment according to the **seven pay test** established by the government, which limits the amount that may be paid into the policy during the first seven policy years. This information should be provided to a policy owner by his or her insurance company.

ENDOWMENT POLICIES AND ANNUITIES

Part of an endowment or annuity payment is taxable and part is not. The nontaxable portion is the **expected return of the principal** paid in. The taxable portion is the **actual amount of payment minus the expected return** of the principal paid in. Since these amounts would be difficult to calculate, the IRS makes up tax tables for this purpose.

By definition, **cost base** is money which has already been taxed. **Tax base** is money which is yet to be taxed. A person investing $1,000 in an annuity is investing

$1,000 cost base. Any interest earned is tax base, but the taxes are deferred during the accumulation period.

The taxation of **annuity contracts** is based upon an **exclusion ratio**. The exclusion ratio is the relationship of the total investment in the contract (cost base) to the total expected return under the contract (calculated based on average life expectancy tables). This ratio (expressed in a percentage) shows how much of each annuity payment is taxable, and how much is not.

Once an annuitant recovers his or her cost base during the annuity period, the total payments received will be taxed at ordinary income tax rates.

If an endowment is paid as a death claim in a **lump sum**, the benefit is not subject to income tax.

If an annuitant dies and the balance of a guaranteed amount is paid to a beneficiary, the payment is not taxable as income until the **investment in the contract** has been received tax free (the amount received by the beneficiary is added to the tax free amounts received by the annuitant, and only any amount which exceeds the total amounts paid in will be taxable).

If an annuitant dies and payments continue to a surviving annuitant under a joint and survivor annuity, the **same percentage** that was excludable before the

first annuitant's death will continue to be excluded from taxes.

When a corporation owns a deferred annuity contract as an investment, it is usually not treated as an annuity contract for several purposes—all income and gains received or accrued during a tax year are taxed as ordinary income. This does not apply to annuities which are owned by a corporation for the purposes of funding pension plans, profit plans, and other plans which are treated differently under the tax laws.

There are special tax requirements for **modified endowment contracts,** including retirement income or semi-endowments. In a **retirement income endowment** policy, the amount payable upon survival (of the endowment period) is greater than the face amount, or cash value. The **semi-endowment** pays, upon survival, one half the sum payable if the insured dies during the endowment period. Because the investment return may be greater than the amount invested, the tax considerations can be complicated.

ESTATE TAX ISSUES

Whether the life insurance proceeds will actually be taxed in accordance with federal state tax laws will be dependent on the deceased's **estate status.**

There are **deductions and exemptions** which may be

applied to adjust a person's estate for tax purposes. For example, there is a unified tax credit of $192,800 (which roughly equals a $600,000 exemption), which is a dollar-for-dollar reduction in gift and estate taxes due.

> Other estate planning techniques, such as the use of trusts and gifts, can also reduce the size of a person's taxable estate.

Since 1916, the federal government has levied a tax against the estate of any individual who has recently died. Currently, the maximum amount of that tax is fifty percent. One exception to this is the marital deduction. **An entire estate may be left to a surviving spouse with no tax consequence.**

On the business side, **Section 303 stock redemption** is a special strategy which permits a corporation to partially redeem a shareholder's stock for purposes of providing cash to cover **estate settlement** costs. Tax laws generally require that stock redemptions be totalled to avoid taxing the proceeds payable to the family as a dividend. The Internal Revenue Service will permit a partial redemption by the corporation to pay funeral expenses, taxes and related estate settlement costs.

TAX AND GROUP LIFE POLICIES

A variety of special tax rules apply to life insurance products which are provided as **benefits to employ-**

ees. Generally, the cost of the first $50,000 of group term life insurance coverage provided to an employee by an employer is not taxable to the employer. The cost of life insurance coverage in excess of $50,000 is taxable as **income to the employee.**

To the extent that an employee is taxed on the cost for **incidental life insurance** protection, the employee only pays a tax on the cost for pure protection.

For cash value insurance, the taxable cost would be the one year term rate for the amount of protection at risk (face value minus accumulated cash value), regardless of the premium actually being paid by the plan. For term insurance protection, the entire actual cost for protection would be taxable to the employees, because that is the cost for pure protection.

Deferred compensation is an executive benefit which enables a highly paid corporate employee to defer current receipt of income such as an executive bonus and have it paid as compensation at a later date (retirement, death or disability) when—presumably—the employee will be in a lower tax bracket. Generally, the employee will enter into an agreement with the employer which specifies the amount of money to be paid, when it will be paid and the conditions under which the deferred compensation may not be paid.

The agreement will specify that the amount deferred will be paid as a retirement benefit or in the event of

the premature death or disability of the employee. It will further indicate that the individual will forfeit the right to this sum of money if he or she leaves the employer except for retirement, death or disability.

The advantage of this agreement for the employee is avoidance of **current taxation** since receipt of the money is deferred. This is allowed by IRS Section 457. However, there are some disadvantages. Usually, deferred compensation is a nonqualified plan and, as such, it may be funded or unfunded.

Another use of life insurance is for **charitable purposes**. In accordance with tax laws, a policy owner may purchase a life insurance contract on his or her life, pay the premiums and designate a charitable organization as the beneficiary; such as a church, school, hospital or similar organization. Generally, the premium paid by the insured-donor is tax deductible.

CONCLUSION

If insurance proceeds are included in an estate, they increase the value of the estate subject to taxation. When choosing an amount of insurance to protect your estate, it is important to have a basic understanding of how taxation may affect your life insurance. This chapter went over a few reasons why it is important to consider taxes when purchasing a life insurance policy.

ACCELERATED BENEFITS AND OTHER CLAIMS ISSUES

INTRODUCTION

Buying the right policy is only half of the life insurance challenge. Making a claim successfully is the other—and probably more important—part.

During the insured person's lifetime, the owner may select from several different options for paying the **proceeds of a life insurance policy** to beneficiaries. The most common of these include:

- lump sum,

- interest only,

- total amount spread over several years,

- fixed amount every year for several years, or

- lifetime income.

This is important to consider where the beneficiary may not be experienced in investing large sums of money, where minor children are involved or when

the insured is clear on specific goals. In any of these situations, you may want to request one of the scheduled distribution plans.

Investment-type insurance can pose some complicated claims issues. When an insured person dies, any unpaid amounts which are guaranteed will be paid as a **single lump sum** to the insured's estate—unless other arrangements have been made. This applies to the current value of any remaining installments under the **fixed period option** or **life income with guaranteed period option** of annuities and similar tools.

Example: A beneficiary who was receiving payments under a 10-year fixed period option dies during the sixth year, so the present value of the remaining payments will be paid to the beneficiary's estate.

Another example: If the same beneficiary had requested that upon premature death the remaining payments continue to be paid in installments to another person (a *contingent beneficiary*), and the insurance company approved, the remaining payments would be paid in this manner to the other person.

A caveat: These provisions for payment following the death of an insured person only apply if there are **guaranteed amounts** unpaid. Nothing would be payable under the **straight life income** or upon the death of the last survivor under a **joint life income** annuity.

STRUCTURED SETTLEMENT OPTIONS

Structured settlements provide alternatives to receiving the policy proceeds in a lump sum. The **policy owner** has the right to elect one or more settlement options while the insured is alive. If the insured dies when no election is in effect, the **beneficiary** may elect a form of settlement.

The **fixed period option** may be a logical choice if your beneficiary needs temporary security and not a lifetime income if you die. If one or more children are named as the beneficiary, it might be desirable to only provide financial assistance until they finish their education, begin their own careers, and reach independence.

The **life income option** is designed to satisfy an entirely different need—the need for lifetime income. It is frequently elected as the form of payment for a death benefit to a **surviving spouse**, or for payment of cash values to an insured who lives to retirement age.

> The amount of the scheduled installments is based on the adjusted age of the payee when benefit payments begin and the remaining life expectancy (insurance companies calculate this by using something called *mortality tables*). The younger a person is when benefits begin, the smaller the amount paid—because the insurance company expects to continue paying longer.

The **straight life income** option continues to pay for as long as the beneficiary lives, but all obligations of the insurance company end as soon as that person dies. Under this method, a person could die after receiving a single installment, or live far beyond normal life expectancy and collect many times the amount of premiums paid in.

This option may also be elected with a **guaranteed period** (also known as a **period certain**), in which case payments will be guaranteed for a specified period of time even if the payee dies sooner.

> A guaranteed period helps offset the concern of some people that they may die before receiving the insurance benefits paid for. But since the insurance company is no longer dealing only with life expectancy, it must set some funds aside to cover the possibility that it will continue payments beyond a person's death. For this reason, a guaranteed period will reduce the benefit payments—the longer the period guaranteed, the smaller the benefit.

Under the **interest** option, the insurance company holds the entire proceeds and makes period payments of the earned interest only. The **interest rate** may be flexible but a minimum rate of interest is usually guaranteed in the policy.

This option might be elected if a beneficiary, such as a surviving spouse, was **financially secure** and had little need for the proceeds. With the approval of the insurance company, you might specify that the proceeds will be paid to another person (such as **surviving children**) upon the death of the beneficiary.

Under the **fixed amount** option, you choose the dollar amount of the benefit payment. This fixed amount will be paid periodically until the entire proceeds are exhausted. Interest, at a minimum guaranteed rate, will be added to the proceeds annually.

Payments may be received under a combination of options. Elections of settlement options are made in the same manner as changing a beneficiary—a written notice to the insurance company. Election by an entity other than an individual (such as a trust or an estate) is allowed only if the insurance company consents.

A number of **miscellaneous provisions** apply to settlement of the proceeds. Total proceeds of under $5,000 payable to any one person will be paid as a single sum. If **scheduled payments** would be less than $50, the payment period will be lengthened so that at least $50 will be paid.

The **life income** or **joint and survivor income** options apply only if the policy owner is the insured person or a beneficiary who has survived the insured. **Proof of age** is usually required when a lifetime income will be paid, because age affects the amount of the payments.

Generally, a beneficiary cannot **assign installment or interest payments** to someone else and may not **withdraw proceeds** which are to be held by the insurance company under the option selected. However, exceptions may be permitted if requested by the policy owner and agreed to by the insurance company.

> **Example:** If you elect the interest option for payments to a beneficiary, the beneficiary would receive interest only and never have a right to withdraw the principle of his or her benefit. But, if you direct that the beneficiary may be permitted to withdraw a specific dollar amount or percentage of the proceeds for special needs (such as education or purchase of a home) and the company agrees, the beneficiary would be permitted to withdraw some of the proceeds.

Under all options which provide **scheduled payments**, the benefits may be paid monthly, quarterly, semi-annually, or annually. The fixed period option pays **equal installments** for a specified number of years—for example, 10 years or 20 years. Amounts to be paid are determined by the number of years selected and in-

terest earnings on the unpaid balance at a rate speci-fied in the policy. Naturally, the longer the payment period, the smaller the benefit because the proceeds have to last longer.

Just about every life insurance policy contains **settlement tables**, which show dollar amounts per $1,000 of insurance for the option selected. These are simply rows of numbers representing periods of time, adjusted ages of insured people, and benefit amounts. We do not reproduce the tables here, but we will give you some examples.

> **Example:** Under a 20 year fixed period option, the policy would pay a monthly installment of $5.51 per $1,000 of insurance. For a $100,000 policy, this would equal $551 in monthly income, or $6,612 annually, for 20 years.

ACCELERATED BENEFITS

If you have a terminal illness, a life insurance policy may be your last substantial source of money. The life insurance benefits may be made available for medical expenses and living expenses prior to death through **accelerated benefit provisions** or **viatical settlement agreements.**

Accelerated benefits are living benefits paid by the insurance company which reduce the remaining death benefit. The government does not currently consider accelerated death payments to be taxable income, and the policy owner can get between 50 and 95 percent of the policy's face value.

Under a viatical settlement, the policy owner sells all rights to the life insurance policy to a **viatical settlement company**, which advances a percentage (usually 60 percent to 80 percent) of the eventual death benefit. The viatical settlement company then receives the death benefit when the insured person dies.

Unlike accelerated benefits, proceeds from viatical settlements are considered **taxable income** by the government.

Accelerated death benefits may require a life expectancy of one year or less. Viatical settlements may be available for a person who has up to five years to live.

LONG-TERM CARE COVERAGE

Long-term care (LTC) insurance, which reimburses health and social service expenses incurred in a convalescent or nursing home facility, is often marketed as a **rider** to a life insurance policy. In many respects, this coverage resembles an accelerated benefit.

LTC rider benefits usually include the following **provisions:**

- **elimination periods** of 10 to 100 days,

- **benefit periods** of 3 to 5 years or longer,

- **prior hospitalization** of at least three days may be required,

- benefits may be triggered by impaired **activities of daily living,** and

- levels of **covered care** include skilled, intermediate, custodial, and home health.

In addition, certain **optional benefits** may also be provided such as adult day care, cost of living protection, hospice care, etc.

The accelerated benefit or **living needs clause** combines life insurance and LTC benefits, drawing on the life insurance benefits to generate LTC benefits. In a sense, it's like borrowing from the life insurance to pay LTC benefits.

Under the LTC option, up to 70 to 80 percent of the policy's death benefit may be used to offset nursing home expenses. Under the Terminal Illness option, 90 to 95 percent of the death benefit may be used to offset medical expenses. Of course, payment of LTC benefits reduces the face amount of the life policy.

CONCLUSION

How the proceeds of a life insurance policy are paid is a common **source of litigation**. Issues involve everything from the terms chosen by the policy owner to misstatements made in an insurance application.

In recent years, though, the key issue that has been raised about life insurance proceeds has been making them available to policy owners before insured people die.

Life insurance guarantees that a **specific sum of money** will be available at exactly the time you need it. On a personal level, life insurance can be used to provide financial security when it may be your last substantial source of money.

This chapter discussed a few of the options you have if an illness occurs—and how benefits can be made available for medical expenses and living expenses prior to death.

CHAPTER 13

HOW INSURANCE COMPANIES PRICE COVERAGE

INTRODUCTION

To understand how insurers set their prices, imagine a hypothetical life insurance company starting from scratch. When customers buy insurance from the company, it isn't betting on a client **living a long time or dying tomorrow**. Its management knows that out of 1,000 34-year-old males, only two will die this year.

If 1,000 34-year-old males want to buy a $1,000 policy each, the company knows it will pay $2,000 in death benefit claims during the next twelve months.

Therefore, the company would have to charge $2.00 per $1,000 of insurance to cover **mortality costs**. This is a key part of the premium. Next year, out of one thousand 35-year-old males, 2.11 are expected to die, so the premium will go up a little bit. By the time the men are 75, 64 out of the 1,000 will die—so the mortality charge is much higher.

The insurance company also has to pay rent, salaries, overhead, etc. These **operating and administrative expenses** are added into the premiums.

It would be risky if the company didn't keep a **reserve fund** in case of unexpected changes in mortality or income. If an earthquake or some other catastrophe struck and the company didn't have enough to pay all the resulting claims, it would go bankrupt. So, the company adds an additional amount to the premiums it charges—to guarantee its reserve.

The company needs to sell its products—so it has **sales expenses**: commissions, advertising, promotion, etc. It adds these expenses to the premium.

The company has to charge premiums for our insurance that will cover all of these costs.

THE UNDERWRITING PROCESS

Underwriting is the process of selection, classification and rating of insurance risks. Simply put, underwriting is a **risk selection** process.

The selection element of the process consists of **gathering and evaluating information and resources** to determine how an individual will be classified—standard or substandard. Once this part of the underwriting procedure is complete, the policy will be **rated** in terms of the premium which the policy owner will pay. The policy will then be issued.

An underwriter's job is to use all the information gathered from many sources to determine whether or not to accept a particular applicant.

The underwriter must exercise judgment based on his or her years of experience to read beyond the facts and get a true picture of your lifestyle. Are there any factors (occupation, hobbies, lifestyle) which make this individual likely to die before his or her natural life expectancy?

An underwriter cannot, and is not, expected to foresee all circumstances. However, the underwriter's purpose is to protect the insurance company insofar as he or she can against adverse selection— very poor risks, and those parties with fraudulent intent.

SOURCES OF UNDERWRITING INFORMATION

The underwriter has various sources of information to provide the necessary information for the risk selection process. These sources include:

- the application,

- medical exams and history,

- inspection reports,

- the Medical Information Bureau (MIB),

- the agent or salesperson.

The form of the application may differ from one company to another. However, most applications provide the same basic information.

Part 1 of the application asks for general or personal data regarding the insured. This would include such information as: name and address, date of birth, business address and occupation, Social Security number,

marital status, and other insurance owned. In addition, if the applicant and the insured are not the same person, then your name and address would be included here.

Part 2 of the application is generally designed to provide information regarding the insured's past medical history, current physical condition and personal morals.

Part 2 also requires information regarding the current health of the insured by asking for current medical treatment for any sickness or condition and types of medication taken. The name and address of the insured's physician is also required.

Usually Part 2 will also include questions regarding alcohol and any drug use by the insured. Avocations and high risk hobbies are also usually reported here.

If the amount of insurance applied for is relatively high, the proposed insured may be required to take a medical examination—and Part 2 is completed as part of the physical exam.

Increasingly, underwriters are relying on paramedical exams and blood tests for information in order to accurately evaluate a health risk. Blood testing is almost universally used to determine cholesterol levels, elevated liver enzymes, and the presence of AIDS or HIV infection.

Another source of medical information available to the underwriter is an **Attending Physician's Statement (APS)**. After a review of the medical information contained on the application or the medical exam, the underwriter may request an APS from the proposed insured's doctor.

Usually, the APS is designed to obtain more specific information about a particular or potential medical problem.

Some simplified forms of life insurance require **no medical exam** and only ask very **basic health-related questions** on the application. Usually this type of insurance is only available in **low face amounts**, to minimize the impact of **adverse selection**.

The application will also record information regarding the policy owner's choices with regard to the mode of premium (monthly, annually, etc.), the use of dividends and the designation of a beneficiary.

Finally, the signatures of the insured (and the policy owner if different from the insured) are required in the appropriate places on the application.

To supplement the information on the application, the underwriter may order an inspection report on the applicant from an independent investigating firm or credit agency, which covers financial and moral information. This information is used to determine the insurability of the applicant. If the amount of insurance applied for is average, the inspector will write a general report in regard to your finances, health, character, work, hobbies, and other habits. The inspector will make a more detailed report when larger amounts of insurance are requested.

Another source of information which may aid the underwriter in determining whether or not to underwrite a risk is the **Medical Information Bureau (MIB)**, based in Westwood, Massachusetts. This is a nonprofit trade association which maintains medical information on applicants for life and health insurance. The MIB has 650 member companies that write 80 percent of the health insurance and 99 percent of the life insurance policies in the U.S.

MIB information is reported in code form to member companies in order to preserve the confidentiality of the contents. The report does not indicate any action taken by other insurers, nor the amount of life insurance requested.

An insurance company may not refuse to accept a risk based solely on the information contained in an MIB report. There must be other substantiating factors which lead an insurer to decide to deny coverage. Beginning in 1995, the MIB must provide explanations to applicants who are denied coverage, allowing consumers to challenge possibly inaccurate information about their medical history.

ADVERSE UNDERWRITING DECISIONS

A risk will be rejected when the insurance company believes the applicant cannot be profitable at a reasonable premium or with reasonable coverage modifications.

In recent years, there have been various state and federal court decisions holding that sex cannot be used as a factor to determine a life insurance or annuity policy premium.

As a response to gender discrimination, the Norris Act was passed into law in the late 1970s, prohibiting the use of gender as a rating factor. In the past, using sex as a factor in determining rates generally resulted in women paying lower life insurance premiums than men.

Acquired Immune Deficiency Syndrome (AIDS) is beginning to have a large impact on the insurance industry. The costs associated with AIDS are those of **premature death and medical costs** including long hospital stays and very expensive drug treatments. These costs affect medical, disability, and life insurance coverages.

AIDS testing prior to policy issuance has become a common underwriting requirement. Typically, this takes the form of a blood test which is consented to and acknowledged by the proposed insured.

The requirement for AIDS testing will especially hold true for those situations where a large amount of insurance is desired. All companies will set the ages and amounts of insurance as underwriting requirements for physical exams and also blood tests for the AIDS virus.

> In many jurisdictions, HIV testing requires informed consent of the applicant, confidentiality of results, and proper notification procedures.

LOSS RATIOS AND RELATED CONCEPTS

Loss and expense ratios are basic guidelines as to the quality of company underwriting.

A **loss ratio** is determined by dividing **losses by total premiums** received. Loss ratios are often calculated by account, by line of insurance, by *book of business* (all accounts placed by each agent or agency) and for all business written by an insurer. Loss ratio information may be used to make decisions about whether to renew accounts, whether to continue agency contracts, and whether to tighten underwriting standards on a given line of insurance.

An **expense ratio** is determined by dividing an insurer's operating expenses (including commissions paid) by total premiums. When the combined loss and expense ratio is 100 percent, the insurer breaks even. If the **combined ratio** exceeds 100 percent, an underwriting loss has occurred. If the combined ratio is less than 100 percent, an underwriting profit, or gain, has been realized.

Example: The ABC Insurance Company realizes $3 million in underwriting losses for all term insurance policies. This same block of business also generates $10 million in premium. The loss ratio would be calculated as follows:

Loss Ratio = Losses/Premiums

Loss Ratio = $3 million/$10 million = 30 percent

Further, assume that the ABC Insurance Company has operating expenses totaling $2 million for this same block of term insurance. The expense ratio would be:

Expense Ratio = Operating Expenses/Premiums

Expense Ratio = $2 million/$10 million = 20 percent

The combined loss and expense ratio equals 50 percent. Thus, the ABC Insurance Company has an underwriting gain or profit on this block of term insurance.

Adverse selection exists when the group of risks insured is more likely than the average group to experience loss.

Example: In a randomly-selected group of 1,000 25-year-old individuals, only two might be expected to die in a given year. However, human nature is such that many healthy 25-year-olds do not see the need to buy life insurance and prefer to spend their money elsewhere. It is only those 25-year-olds who are ill or perhaps employed in dangerous occupations who are likely to buy insurance. An underwriter must take care not to accept too many of these poorer-than-average risks or the insurance company will lose money.

Besides the problem of adverse selection, the underwriter must guard against **moral hazards and morale hazards.**

A moral hazard is the likelihood of an applicant to misrepresent himself or herself to the insurance company with reference to health status, occupation or other pertinent information. In other words, a moral

hazard deals with an individual's tendency to **lie or be dishonest.**

A morale hazard is a person's indifferent attitude toward risk.

Example: An insurance applicant with a history of speeding tickets and drunk driving would display an indifferent or apathetic attitude toward his or her own health and well-being and thus present a morale hazard to the underwriter.

CLASSIFICATION OF RISKS

Risk classification refers to the determination of whether a risk is **standard or substandard** based on the underwriting or risk evaluation process.

Standard risks are those who bear the same health, habit, and occupational characteristics as the persons on whose lives the mortality table used was compiled. Basically, a standard risk is simply an average risk.

About 90 percent of individuals covered are standard risks. Less than 2 percent of individuals applying are turned down for coverage completely. That leaves about 8 percent that fall somewhere in between.

More and more high risk cases are becoming acceptable (and, also, many conditions once considered **high risk** are now, on the basis of more experience, being accepted as **standard**). Today it is a rare case when coverage cannot be found anywhere for almost any risk.

Most insurers offer special but higher rates to persons who are not acceptable at standard rates because of health, habits or occupation. This is sometimes called **substandard** or **extra risk** insurance.

> Some companies have coined euphemistic names for it in order to avoid the rather insulting implication that persons offered this type of coverage are substandard.

There are several methods of determining the extra rate for the substandard class of risk:

- **Rated-Up Age**. This assumes that the insured is older than his or her actual age, which is a way of saying that he or she will not live as long as a standard risk. Thus an impaired risk of age 35 may be issued a policy as applied for but with the rate of age 40. While having the merit of simplicity of handling, this method is no longer widely used.

- **Flat Additional Premium**. A constant (that is, not varying with age) additional premium is added to the standard rate.

- **Tabular Rating.** Applicants are classified on the basis of the extent to which mortality of risks with their impairment or degree of impairment exceeds that of the standard risk. Percentage tables are developed and used to calculate the amount of extra premium to be charged for any class of impaired risks.

Extra percentage tables are usually designated as *Table A*, *Table B*, etc. Each usually reflects about a 25 percent increase above 100 percent—or standard. Insurers vary in the number of tables on which they will accept risks. One may not accept anything lower (or *higher*, depending on your perspective) than, say, *Table C* (175 percent). Another may write through *Table F* (250 percent). Companies can be found that will write up to 1,000 percent—and even higher.

- **Graded Death Benefits.** The policy owner pays the standard premium for, say, $20,000 of insurance but receives a policy with a face amount of perhaps $15,000. After some time has elapsed the company may increase the amount of insurance periodically and, when the company considers the substandard condition to no longer exist, the full $20,000 of coverage would be granted.

If a substandard risk presents an above average risk of loss, a **preferred risk** presents a below average risk of loss. In an effort to encourage the public to practice better health, the insurance industry has developed preferred risk policies with lower (or preferred) premium rates.

Those applicants who may be eligible for preferred risk classification are those who:

- work in low risk occupations and do not participate in high risk hobbies (scuba diving, sky diving, etc.),

- have a very favorable medical history,

- presently are in good physical condition without any serious medical problems,

- do not smoke, and

- meet certain weight limitations.

DETERMINING PREMIUMS

The final step in the underwriting process is the **rating of the risk** or the **determination of the premium**. There are three factors used in determining life insurance rates:

- mortality,

- interest, and

- expenses.

If an underwriter could predict **exactly how long each insured person would live**, he or she could charge a premium for each risk that was precisely correct for covering the policy face amount, and expenses, while taking into account the interest to be earned on the premium paid.

Of course, an underwriter cannot do this on an individual policy—but he or she can predict the **probability** of numbers of deaths for a large group of people by using a standard mortality table, such as the **1980 Commissioners' Standard Ordinary Mortality Table.** The table is based on statistics kept by insurance companies over the years on mortality by age, sex and other characteristics.

The **deaths per 1,000 (or mortality) rate** is taken from the mortality table and converted into a dollar and cents rate. For instance, if the mortality rate for a particular age group is 3.00, it means, on the average, three out of every 1,000 can be expected to die at that age in the next year.

The **basic cost of life insurance** is the cost of mortality. However, in constructing a rate, interest enters the equation. It is assumed that all premiums are paid at the beginning of the year and all claims paid at the end. Therefore, it becomes necessary to determine how much should be charged at the beginning of the year, assuming a given **rate of interest**, to assure enough money at the end of the year to pay all claims.

Using the cost of mortality and discounting for interest, there is enough money to pay claims—but there's no money to pay operation expenses. The premium without expense loading is a net premium. (Do not confuse net as it is used here with the same term sometimes used to indicate a participating premium minus dividends paid.)

EXPENSE LOADING

An expense loading is added to the **net premium** in order to:

- cover all expenses and contingencies,
- have funds for expenses when needed, and
- spread cost equitably among insureds.

Loading consists of four main items:

- **Acquisition Costs.** All costs in connection with putting the policy on the books are charged as incurred in the insurance accounting. In most cases, these costs will be so proportionately high in comparison to ensuing years that they must be amortized over a period of years. One of the highest **acquisition costs** is the agent's first year commission.

This is the reason a policy that lapses in the first two or three years creates a loss for the insurer. It has not yet recovered acquisition costs.

- **General Overhead Loading.** Clerical salaries, furniture, fixtures, rent, management salaries, etc., must be considered when determining expenses. The allocation of these costs is unaffected by the size of the premium, probably little affected by the face amount, but is most likely affected by the **number of policies**.

- **Loading for Contingency Funds.** Once a level premium policy has been issued, the premium can never be increased. However, unforeseen contingencies could make the rate inadequate. Assessment companies reserve the right to charge additional premiums in such a case. Legal reserve companies establish contingency reserves to draw on in such cases.

- **Immediate Payment of Death Claims.** In rate-making, it is assumed that all claims are paid at the end of the year. This is not literally true, of course. Relying on the **law of large numbers**, it is safe to assume that death claims will be spread throughout the year. Therefore, theoretically, all claims will be paid six months before the end of the year. Allowance must be made for this loss in the expense loading.

THE GROSS ANNUAL PREMIUM

The **gross annual premium,** the amount the policy owner actually pays for the policy, equals the mortality risk discounted for interest, plus expenses.

By formula:

Gross Premium = Mortality – Interest + Expenses

Net Premium = Mortality – Interest

The **mortality** risk factor increases with age. This is the reason that some life insurance policy premiums increase periodically.

The **level premium** concept was devised to solve this problem of increasing premiums. Mathematically, the level premiums paid by the policy owner are equal to the increasing sum of the premiums caused by the increased risk of mortality.

In the early years of the policy, the level premiums paid are actually more than the amount necessary to cover the cost of mortality. Conversely, in the later years of the policy, the premiums paid are less that the amount necessary to cover the increased cost of mortality. This shortage in the later years of the policy is accounted for by the overcharges (plus interest earned) in the early policy years.

RESERVES

Reserves are **accounting measurements** of an insurance company's liabilities to its policyholders. Theoretically, the reserve is the amount together with interest to be earned and premiums to be paid that will exactly equal all of the company's contractual obligations.

A life insurance reserve is a **fixed liability** of the insurer. This liability represents the insurer's promise to pay the face amount of the policy at some future time. By law, a portion of every premium must be set aside as a reserve against the future claim from the policy as well as other contractual obligations such as cash surrender and nonforfeiture values.

Insurance companies demonstrate their **solvency** to state insurance regulators by showing their assets as well as adequate funds to cover their **reserve obligations**. In addition to its assets, the insurer must show that it will continue to receive future premiums plus interest in order to cover its reserve obligation.

By law in most states, the insurance commissioner requires that a specific reserve be maintained if a company is to be solvent. The reserve must be calculated using a mortality table and an interest specified by the Commissioner. Most states require that premiums be calculated using the 1980 Commissioner's Standard Ordinary table. In addition, the estimated investment return or interest rate paid on the premiums will also be determined by the Insurance Commissioner. Usually, a very conservative interest rate is specified.

COMMISSIONS DIFFER

Another important point in how companies set their prices is how they pay their salespeople. As a general rule, mutual life insurance companies pay 6 percent of revenues in **commission** while stock companies pay between 10 and 17 percent.

If you are being presented with stock company products, the agent may receive up to 50 percent more commission than a similar mutual company's product. Lower commission means lower company expenses.

No-load insurance products typically pay the same sales expenses as the stock companies, but they don't call the expense commission. So, the term *no-load* is mostly a sales gimmick borrowed from the mutual fund industry—company financials reveal similar or higher marketing costs in most cases.

Whether an insurance company calls an expense a commission or advertising should make no difference to you, as a consumer.

Company **operating expenses** differ significantly. Whether the company is an auto manufacturer or a law firm, overhead and salaries differ in all companies. Some companies are simply more efficient than others.

Insurance companies are required to publish
their operating expenses. When you compare
companies, ask to see the operating expenses
for each.

CONCLUSION

All insurance companies price their policies to cover
mortality and operating costs. What happens after
that makes each company unique. Some will keep
prices low in order to sell a high volume of policies—
others will build in more cost drivers to weed out cer-
tain kinds of risks or bolster profits. Some pay higher
sales commissions, some lower.

As a smart consumer, your job is to ask the right ques-
tions which will help you identify the strategies a com-
pany is using to price the life insurance it sells. This
can help you choose between similar policies. It can
also suggest what a specific company expects from its
products and the marketplace. This can give you some
idea of what to expect from the company over the
course of several years.

CHAPTER 14

TIPS FOR SMART CONSUMERS

INTRODUCTION

In an increasingly competitive insurance market, some companies—and their agents or salespeople—will press the limits of legal and ethical sales practices. It's up to each insurance consumer to proceed carefully. In this chapter, we will conclude our study of the life insurance business with a review of tips for smart consumers.

The first—and most common-sense—tactic of the smart consumer is to **read the insurance policy** he or she is buying carefully. In fact, most policies incorporate this advice into their standard form.

For example:

> This contract is a legal contract between the contract owner and the insurance company.
>
> Read your contract carefully. It sets forth, in detail, the rights and obligations of both you and your insurance company. It is therefore important that you read your contract carefully.

EVALUATING FINANCIAL STRENGTH

The most rigorous and easiest rating service for consumers to understand is The Weiss Report. If a company is rated $A+$, A, or $A-$ by Weiss, you can safely conclude that the company is financially strong.

However, there are many rating services where an A rating doesn't mean much. In fact, most companies can claim an A rating by some service. In the months prior to its bankruptcy, Executive Life was rated A by several major rating services.

If a company has a weak Weiss rating, an agent or salesperson will typically refer to Duff & Phelps, A.M. Best, Standard and Poor's or Moody's ratings report. The following form should be useful for comparing the key financial numbers of different insurance companies.

EVALUATION FORM

	Top Co.	Proposed Co.
SIZE OF COMPANY IN BILLIONS	_____	_____
FINANCIAL STRENGTH	_____	_____

	Top Co.	Proposed Co.
Weiss Rating	_____	_____

COMPANY EXPENSES
(Low numbers are best)

	Top Co.	Proposed Co.
5 year avg mortality ratio	_____	_____
5 year avg commission	_____	_____
5 year avg expenses/ premium	_____	_____
5 year mortality expense	_____	_____

COMPANY NON-EXPENSE FACTORS
(Higher numbers are best)

	Top Co.	Proposed Co.
percent added to reserve/ savings account percent of dividends to policyholders	_____	_____
percent of dividends to stockholders	_____	_____

SALES PRESENTATIONS

Insurance agents and salespeople are subject to a number of laws and regulations which shape their behavior during **sales presentations**.

Example: Agents are prohibited from misrepresenting policy terms (specifically, this usually applies to exaggerating projected benefits).

In addition, agents are often required to disclose facts about **information practices** and the products they are proposing for sale. In many jurisdictions, agents must provide prospective policy owners with a **policy summary** and a **buyers guide** at the time of application.

A policy summary is a document that summarizes the coverages, benefits, limitations, exclusions, and terms of the policy proposed for sale.

A buyers guide is a consumer publication that describes the type of coverage being offered, and provides general information to help the applicant compare different policies and reach a decision about whether the proposed coverage is appropriate.

TRICKS AND PITFALLS TO AVOID

The basic sales presentations which insurance salespeople and agents use are called **sales illustrations**. They can be very misleading. Problems crop up especially because some companies:

- make overly aggressive return projections,
- arbitrarily assume future mortality improvements,
- compound mortality improvements into the future,
- assume future lapses to dramatically improve projections,
- fabricate future earnings that have no historical basis, and

- mistreat existing policyholders to improve future projections for new policyholders.

Financial assumptions are the magic of actuaries and life insurance companies. By changing small assumptions, actuaries can make a mouse look like an elephant down the road.

> **Example:** A dollar invested at 5 percent every year for 40 years grows to $126; the same dollar invested at 10 percent every year becomes $486 in forty years. That's a difference of nearly four-fold caused by only a 5 percent change in performance assumption.

The important factor to remember: Insurance companies are **not required** to meet the projections included in sales illustrations. In the end, you simply cannot rely on illustrations for comparison.

> It's far better to rely on the company's actual historical performance than a particular policy or illustration. Compare histories, not projections.

Actual histories are available. If a company cannot or will not provide its **investment performance and financial histories** for comparison, look for a company

that will. If your agent cannot provide this information, find an agent who can.

THE FOUR KEY DECEPTIONS

One: Premium Deception

The lowest premium may be the lowest premium only because the company made unrealistically aggressive assumptions.

Suppose you are a male 45, and have told the agent you want $500,000 of coverage and want to pay premium for only 10 years—then the premium will vanish (that is, the policy will become self-financing). The agent shows you two different companies:

| Company A | $4,772 | 10-year vanish |
| Company B | $7,285 | 10-year vanish |

This appears to be an easy decision...right? Same amount of insurance, same payment period, but dramatically different premiums. Actually, Company B may be a better choice.

What happens when a company arbitrarily decides to assume **policyholders will live longer**? Premiums will drop dramatically. Let's look at the effect on premium for a male 45, based on **improved mortality**.

MALE AGE 45
$500,000 FACE AMOUNT
10 PAYMENTS, 6.25 percent INTEREST RATE

Life Expectancy	Required Premium	Age
35 years	$7,295	80
39 years	$6,082	84
43 years	$4,772	88

As insurance companies try to out-illustrate each other, some have begun fabricating new mortality tables that have no basis in reality.

How can insurance companies do this? Imagine that an insurance company can show a one percent mortality decrease in the past five years. It can assume one percent decrease compounded for 80 years and say the new mortality is **supportable based on historic trend.**

Two: Cash Value Deception

The highest cash value projected for 5, 10 or 40 years in the future may be the result of manipulating mortality, lapse ratios, interest assumptions, expense projections, persistency bonuses, etc.

You are looking at two illustrations. The premium is the same for both. The face insurance amount is the same for both. After 20 years, the cash values are as follows:

COMPANY A	COMPANY B
$69,300	$92,298

You might assume that company B is a better value. But there's very little reason to make that assumption.

Beware: Fast-growing projected cash value doesn't mean lower cost. It may simply mean aggressive assumptions on the insurance company's part.

Whole life premiums typically assume a guaranteed 4 percent interest. They may perform substantially better, but the premium is calculated on a **worst case scenario** of 4 percent. This is why whole life premiums are higher than universal life. They're also guaranteed, so they are safe assumptions.

Universal life premiums typically assume a non-guaranteed **current rate**. Obviously, if you assume a 6 or 8 percent interest income rate, the premium seems lower than if you accept a guaranteed 4 percent rate. But the premium may increase in the future if current interest rates fall.

This kind of interest rate assumption has been a big problem and a big surprise to people who bought universal life insurance in the late 1980s. At that time, interest rates were much higher, so premiums were low. When rates fell, policies collapsed.

Three: Vanishing Premium Illustration Deception

Many smart consumers look for **vanishing premiums.** These are usually associated with whole life or related policies that build enough cash value in 10 or 15 years that their dividends and interest income pay the premiums.

Buying vanishing premiums is expensive in the short run but can make a lot of sense in the long run.

The caveat: The lowest premium or shortest number of years to vanish in a sales illustration may be the result of aggressive—and baseless—assumptions.

Four: Highest Retirement Income Deception

An agent or salesperson can falsely illustrate significant retirement income improvements in a cash value policy by only running the illustration to ages 85, 90 or 95—rather than the usual 100.

The insurance industry has been soundly criticized for making projections look—and sound—like reality. On the bottom of every sales illustration, the law requires a paragraph of disclaimers which say effec-

tively: *Everything you see is a projection, not a promise. These are not estimates or guarantees of future results. Actual results may be better or worse in the future.*

KNOWING THE PLAYERS INVOLVED

It is important to clearly understand all of the **parties** who might be involved and the parts they play in the life insurance process. These might include the applicant, the insured, the policy owner, and the beneficiary. Although these are four separate roles, they may all be played by one person or several people.

> Example: A husband applying for insurance on his own life that benefits his wife is the applicant, insured and policy owner. His wife is the beneficiary.

The term **third-party ownership** refers to a situation where the policy is owned by someone other than the insured.

> Example: A company might apply for insurance on the life of a key employee. In this case, the company is the applicant, policy owner and beneficiary. The key employee is the insured.

PURCHASING STRATEGIES

As with many other products, consumers have a wide range of options when considering which life insurance policy to buy. To make cost-effective selections, there are two basic methods an applicant can follow: the **traditional net cost** method and the **interest-adjusted cost** method. There are advantages and disadvantages to both.

The traditional net cost method adds **premiums expected to be paid over 10 years** (or the maximum number if the term is less than 10 years), then subtracts the cash value expected to be accumulated and dividends to be paid by the end of the 10-year period. This number is averaged (divided by 10, in this case) for a final number referred to as the **average annual surrendered net cost**.

> To do this calculation—or any like it—you should get premium, dividend, and cash value numbers from each of the insurance companies you're considering. Calculations should be compared on a *per $1,000 of insurance* basis.

There are **three main problems** with this calculation. One, it assumes that the policy owner will have the policy for exactly 10 years. The averages would be different for a 20-year period. Two, dividends are only

assumptions. If dividends are higher or lower than predicted, cost averages are affected. Three, this comparison does not take into account when premiums and benefits are paid—the time value of money.

The interest-adjusted cost method is similar to the traditional net cost method, with the exception that it accounts for an interest rate. After the selection of a time period for analysis (such as 10 years) and the selection of an interest rate (such as 5 percent), the calculation proceeds as follows:

- add annual dividends at interest to the cash value at the end of the period,

- divide this amount by an interest factor which converts it to a level annual amount,

- subtract this result from the annual premium.

Even with this method, **comparison of policy costs is still inexact.** Coverages provided may differ in policies and dividend amounts are assumptions only. No policy is cost-effective for its owner if it does not meet that person's (or institution's) needs.

RIDERS AND OTHER MODIFICATIONS

One mechanism that smart consumers use to tailor insurance policies to their needs is through the use of **riders and other modifications** to standard policies.

> Riders take their name from the concept that they have no independent existence. They have force and effect only when they are attached to a policy. A rider is a special provision or arrangement not in the basic policy contract but that has been attached to and made a part of the contract, sometimes for an extra premium. Riders can be used to enhance or add benefits to the policy or they can be used to take benefits away from the policy.

Riders usually require the payment of a relatively small **additional premium** for the benefits provided. But these additional premiums are often less than the cost of a customized policy.

Among the most common kinds of riders:

- **Accidental Death (Double Indemnity).** This provides an additional death benefit and a dismemberment benefit for loss of certain body members, if the death or the loss is due to an accident. The accidental death benefit, usually referred to as the principal sum (the rider's face amount), pays an additional death benefit if the cause of death is due to an accident as defined by the policy. Usually, death must occur within 90 days of the accident for the benefit to be paid.

Example: John has a $10,000 whole life policy which contains the accidental death rider (double indemnity). If he is killed accidentally as defined by the policy, the total death benefit will be $20,000. However, it should be noted that the value of the accidental death rider is $10,000. It is an amount equal to the face amount of the policy. The basic whole life amount of $10,000 is increased by another $10,000 due to the rider.

- **Waiver of Premium.** This provides that, in the event of total disability as defined by the policy, premiums for the policy will be waived for the duration of the disability. The rider is temporary in that it usually expires at the insured's age 65. However, if a total disability occurred prior to the expiration of the rider, the premiums are waived for the duration of the disability.

 There is usually a six-month waiting period before the rider's benefits are payable. This means that the insured must be totally disabled for six months (a few insurers only require three months) and then future premiums will be waived for the duration of the total disability. Once the six-month waiting period has been satisfied, any premiums paid during the waiting period will also be refunded to the policy owner.

A variation of this rider is Waiver of Premium with Disability Income. The same concept applies as with waiver of premium, but this rider will pay a weekly or monthly disability income benefit to the insured in addition to the life insurance premiums being waived.

- **Guaranteed Insurability.** This guarantees that, at **specified dates** in the future (or at specified ages or upon the event of specified occurrences such as marriage or birth of a child), the policy owner may purchase additional insurance without evidence of insurability. The rate for this additional coverage will be that for the insured person's attained age, not the age at which the policy was issued.

 The amount of insurance which can be purchased on the option dates is usually limited to the amount and type of the base policy. If the policy owner had a $10,000 whole life policy with the guaranteed insurability rider, he or she could purchase up to an additional $10,000 of whole life coverage on the option dates.

 The biggest advantage offered by this rider is the opportunity to buy additional amounts of insurance as one's responsibilities and needs change, without proof of insurability.

The option dates are usually the policy anniversary nearest the insured's birthdays at ages 25, 28, 31, 34, 37, and 40. In addition, marriage and the birth of children between the ages of 25 and 40 also trigger additional options.

- **Return of Premium.** This was developed primarily as a sales tool to enable the agent to say, "In addition to the face amount payable at your death, we will return all premiums paid if you die within the first 20 years." The rider is simply an increasing amount of term insurance that always equals the total of premiums paid at any point during the effective years. Technically, the rider does not return premiums but pays an additional amount equal to premiums paid to date of death. The policy owner who purchases the rider is simply buying additional term insurance.

- **Return of Cash Value.** This seldom-used rider was designed to offset the common—though invalid—complaint, "When I die, the company confiscates the cash value." This complaint is based on lack of understanding of the mathematics involved in a level face value life insurance policy. However, if the agent can say, "We can attach a rider returning the cash value in addition to the face amount," the objection is more easily answered than if it is necessary to explain the mathematics involved.

The return of cash value rider is similar to the **return of premium** in that it is merely an additional amount of term insurance that is equal to the cash value at any point while effective. Buying it, the policy owner is simply getting additional term insurance.

- **Cost of Living Adjustment.** This rider is important to people who are in a position to be impacted strongly by inflation. Because of the high inflation years of the 1970s, many policy owners were concerned that the face amounts of policies purchased would not be adequate to cover expenses by the time the death benefit was paid. The cost of living rider **changes the face amount** of the policy each year by a stated percentage, such as 5 percent. This amount is compounded annually.

> This rider can be used to both increase and decrease the face amount of the policy, depending on that year's cost of living. There are limits on the amount the face amount can be decreased, however.

- **Additional Insureds.** These riders are commonly attached to life insurance policies to provide coverage on the lives of one or more **additional insured people**. Usually these are term insurance riders covering a spouse, one or more children,

or all family members in addition to the named insured. Many companies will issue additional insured riders on request. Some companies actively market combination coverage policies for family members as a **family protection policy.**

- **Living Need.** This rider is a recent development in life insurance. It allows a terminally ill individual to obtain part of the insurance proceeds prior to death. To be eligible for this benefit the individual must present medical proof of the terminal illness. Most companies offering this benefit will limit the amount of the insurance proceeds which may be paid in this manner. Most companies **do not charge** additional premium for this rider because it is an advance against the death proceeds for which the policy owner is already paying premiums.

A caveat: Sometimes companies offer a wide rarity of riders and options as sales tools to allow the sales person to focus on the riders and disguise the poor quality of the basic company and product. Beware of agents pushing the unique benefits and riders as compelling reasons to buy the product.

POLICY RECEIPTS

Once the underwriting process is complete and you have been approved, the life insurance policy will be issued by the insurance company. The coverage is not effective until the policy is delivered and the initial

premium has been paid. Smart consumers proceed carefully through this stage of the process.

Often, you will pay the initial premium with the application. When this occurs, the agent will provide you with a receipt for the initial premium and the effective date of coverage will depend on the type of receipt issued.

A few companies use an unconditional or **binding receipt** that makes the company liable for the risk from the date of application. This coverage lasts for a specified time or until the insurer either issues a policy or declines the application, if earlier. The specified time limit is usually 30 to 60 days.

> With a binding receipt, regardless of your insurability, you are covered for a specific period of time following completion of the application and the payment of the initial premium. Use of this type of receipt is rare.

A **temporary insurance agreement** is a type of receipt that provides you with immediate life insurance coverage while the underwriting process is taking place whether or not the individual is insurable.

> **Example:** You submit the initial premium and application and are provided with a temporary insurance agreement which states that coverage is effective immediately and will continue during the underwriting process. If you should die during this period, the coverage is in force regardless of your insurability or risk classification as a result of the underwriting process.

PAYMENT SCHEDULES

Most life insurance companies base their premium payment schedule on a yearly cycle. Although they use a calendar year to figure the base for your premium, it is possible to pay your premium on a semi-annual, quarterly or monthly basis. You may however owe an increased service charge to offset the added expense of processing payments more than once a year.

> An insurance company will usually ask at the time of the application how are you going to pay. Most companies will allow you to change the frequency of your payments at your discretion.

Some companies require a **pre-authorized check (PAC) method** of payment if you choose to pay on a monthly basis. This assures the insurance company that your payment will be received on a timely basis and cuts down on additional paperwork costs.

Direct withdrawal of funds from your checking account has become a standard feature within the life insurance industry. Don't be surprised if your company has this requirement tied to its monthly premium arrangement.

OTHER POLICY CHANGES

At any point during the life of a life insurance policy, the policy owner has the right to change certain provisions. These include:

- the face amount downward,

- the beneficiary/contingent beneficiary,

- the type of plan (if allowed),

- the payer,

- the owner (by sale or gift, transfer or assign the policy),

- the billing cycle.

On the other hand, state laws and regulations prohibit insurance companies from making certain changes in their insurance policies. Among the common things a company can't include...or add:

- a provision that states you have **less than one year** from the time of incident to bring a lawsuit upon an insurance company you are entitled to at least one year;

- a contract provision that permits **cashing out the policy** at time of maturity for less

than the face amount of the policy, including any dividend additions, (the company may subtract any policy loans and overdue premiums);

- a provision which would allow the company to **forfeit the policy due to outstanding loans** or loan interest, if the total owed is less than the loan value of the policy; and

- a provision stating that the agent represents anyone but **the insurance company,** i.e., a provision stating that the writing agent may act or represent the insured person or applicant.

IF YOU'RE UNINSURABLE....

What should you do if you have health problems that make you uninsurable?

If your life insurance application is rejected because of information in an investigative report, you must be notified and given the name and address of the reporting company.

If your health problems are so severe that you are classified as **uninsurable,** or even if a new life insurance policy is just too expensive for you, it's good to know that some companies offer **guaranteed issue** life insurance. This insurance is available in smaller face amounts—like $10,000.

The full face amount is payable in the event of accidental death, but for death from natural causes the benefit is limited to the total of premiums, plus interest, at least for the first few years of the policy. After that, the benefit equals the face amount. Guaranteed issue life insurance is a good solution for covering expenses such as funeral costs for otherwise uninsurable people.

If you are rated a **substandard risk**, there are a number of things you can do to get at least some life insurance coverage.

A life insurance policy may be issued as applied for, modified, or even amended if the applicant does meet the underwriting standards of the insurance company. While uncommon, an insurance company may issue a **waiver** with the policy which states that **death by a particular** event will not be covered. This might be done if the insured person has a particularly hazardous occupation or hobby. More commonly, an insurer might issue a more limited form of policy or at lower limits than that which was applied for.

In the 1980s, to gain a competitive edge in illustrations, some companies began to use **inflated interest rates for universal life and unrealistically high dividend scales** for mutual company illustrations. Illustrations of future performance did not reflect actual history of performance.

ECONOMIC PRESSURES ARE INTENSE

A last caveat: As actual interest rates fell below projections during the late 1980s and early 1990s, consumers became wary of **interest sensitive policies** like universal life. As aggressive assumptions were proved wrong, consumers found their vanishing premiums didn't vanish and their level premium policies required more money.

Some insurance companies concluded that they had to carry out the illustration war in the arcane invisible world of **undisclosed assumptions**. They began to manipulate **mortality assumptions** and **lapse ratios**. These changes can have a big impact on pricing and projected cash values—yet are virtually impossible to debunk because they're undisclosed in compliance documents.

> A small reduction in mortality can create a major lowering of premium. Suddenly, companies that have no history of extraordinary performance are able to out-illustrate everyone else. Other companies then jump in with even more aggressive assumptions.

One trick some insurance companies use to appear more competitive than they are is called **segmentation**. The companies classify their policies by age and change their portfolio management to credit newer policies with higher dividends, lower expenses, and lower mortality assumptions.

> This punishes existing policy owners in order to seduce new ones. Eventually—three or four years later—the new policy owners will become subject to the same treatment that other older customers get.

Some larger mutual companies have acknowledged that they use segmentation. The justification some stock companies offer for withholding actual historical performance—which would reveal segmentation—is that the old policies don't reflect the current plans offered.

CONCLUSION

The way life insurance is sold is changing. It's becoming a price-driven, commodity market. Long-time professionals in the industry aren't sure where the business will ultimately land. A lot of people are getting out of insurance; a lot of those staying are, frankly, scared. More than ever, buyers have to beware.

It's increasingly likely that you'll buy your next life insurance policy over the phone, via computer or through the mail. You'll likely be dealing directly with the insurance company (and even if you use an agent or broker, that person's increasingly likely to be working for a single company). You'll need all the critical tools you can find.

This book has given you the basic tools you need for understanding life insurance—the honest and the slippery. If you following the guidelines and ask the questions we've discussed, you should be able to satisfy your needs...and the needs of the people who depend on your judgment and money.

Good luck.

INDEX